BRITAIN'S HE...

EXMOUTH *to* PLYMOUTH

GARY HOLPIN

South West
Coast Path
Association

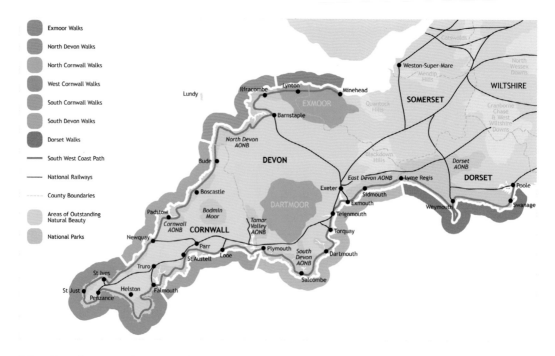

The South West Coast Path Association

The South West Coast Path Association (SWCPA) is the charity that represents all users of the Coast Path, be they long-distance walkers or afternoon strollers, visitors or local residents. As well as providing information about the Coast Path, including a comprehensive annual guide, the Association raises funds to help maintain the best possible standards for the path and its environmental corridor.

A modest annual membership fee will enable you to receive a free copy of the annual guide, which includes a comprehensive accommodation list, as well as newsletters and other updating information about the path, offers of concessions for walking equipment and books – and the knowledge that your subscription will go towards improving this superb resource and its information.

To join the Association online, visit www.southwestcoastpath.org.uk or telephone 01752896237.

First published 2014

Amberley Publishing
The Hill, Stroud
Gloucestershire, GL5 4EP

www.amberley-books.com

Copyright © Gary Holpin, 2014

The right of Gary Holpin to be identified as the Author of this work has been asserted in accordance with the Copyrights, Designs and Patents Act 1988.

ISBN 978 1 4456 2151 7 (print)
ISBN 978 1 4456 2157 9 (ebook)

British Library Cataloguing in Publication Data. A catalogue record for this book is available from the British Library.

Typesetting by Amberley Publishing.
Printed in the UK.

Contents

About the Author

Originally from Gloucestershire, Gary now lives in East Devon and has been a regular visitor to the South Devon coast throughout his life. His earliest visits were regular family seaside holidays to the resorts of Dawlish Warren and Goodrington during the 1970s, and after moving to Devon in 2003 he began walking on the South West Coast Path as a way to explore his new home. He was immediately hooked on the spectacular coastal scenery of the South West and is currently halfway through walking all 630 miles of the path for the second time. On sunny days, Gary can often be found with his camera enjoying the natural splendour of the South Devon heritage coast. For more details on the author, see www.garyholpin.co.uk.

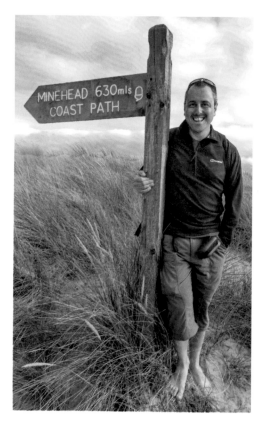

The author after completing all 630 miles of the South West Coast Path (for the first time), at South Haven Point in Dorset.

Introduction

South Devon is the place of memorable family holidays at its splendid seaside resorts, and many readers will have fond memories of its sunshine and sandy beaches, Devon cream teas and cider, and stories of smuggling and pirates. But this landscape contains plenty of clues to how the familiar coastline we see today came to be. From the rocks of its cliffs, providing a snapshot of 400 million years of the history of our planet, to flint tools left in secluded caves by some of the earliest South Devon residents, the coastline provides many hidden clues to its long and sometimes turbulent past.

To the north is the massive granite outcrop of Dartmoor, formed from the remains of ancient volcanoes, and the source of many of the rivers that meander through the Devon countryside before joining the sea along the South Devon coast. These are the rivers whose sheltered estuaries helped early trade to develop, and carried nutrients that enriched the lowland soils and attracted the first settlers to farm the land.

Our journey along the South Devon heritage coast begins at Exmouth. The oldest seaside town in Devon, Exmouth sits at the mouth of the first river on our journey, the River Exe, and is the gateway to the Jurassic Coast. We then travel south around Torbay and the South Hams, passing seaside resorts, stunning coastal vistas and beautiful river estuaries before heading west to end at Plymouth, the largest city in Devon. Along the way, we learn a little of the origins of the places we pass and the stories of some of the people who lived there. As well as learning a little of its history, we also celebrate the natural beauty of this varied and spectacular coastline.

People have chosen this coast for fishing and trade for thousands of years, but for much of that time they chose to live inland, well away from the ever-present dangers of pirates, coastal raiders and violent storms. It was only much later, in safer times, that many of the coastal towns we are familiar with today have their origins. The sea is at the centre of the history of this coast, with superb natural anchorages and sheltered estuaries putting South Devon's ports at the forefront of national defence and the growth of global trade. They were also home to some of our most famous explorers, such as Sir Francis Drake and Sir Walter Raleigh, who led the Elizabethan age of global discovery. More recently, the sea has been at the centre of the new tourist industry, which developed as early as the eighteenth century and endures to the present day.

Much of the South Devon coast is protected in order to help preserve its natural beauty for future generations. It is recognised by Natural England as part of Britain's National Heritage Coast, many areas are within designated Areas of Outstanding Natural Beauty, and large swathes of clifftop habitat are owned and managed by the National Trust. The coastline also includes a number of National Nature Reserves and many Sites of Special Scientific Interest, reflecting the vital role it plays in protecting some of our most important natural heritage.

All 103 miles of the South Devon coast can be explored on foot along part of the South West Coast Path. In total, the path covers 630 miles of stunning coastal scenery, all the way from Minehead in Somerset, via Land's End and finally ending at South Haven Point in

Dorset. Originally created by the footsteps of nineteenth-century coastguards in their battle to catch smugglers, it is now arguably one of the world's finest long-distance walking trails and a perfect way to explore the beauty and history of the South Devon coast.

This is a coastline of sheltered coves and remote headlands, secluded valleys and wooded estuaries, towns clinging to hillsides above picturesque harbours, and sandy beaches beside bustling seaside resorts. The landscape we see today is a product of truly ancient rocks, sculpted by the drift of continents over millions of years and the endless pounding of waves, and finally shaped by hundreds of generations of people making this coastline their home.

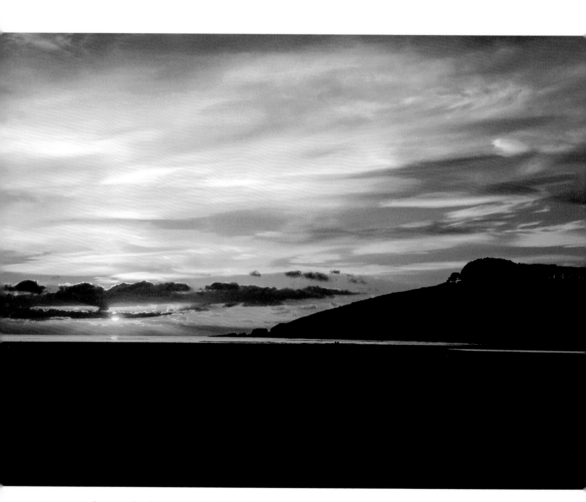

Sunset at the mouth of the unspoiled River Erme.

The South West Coast Path

One of the best ways for visitors to explore the 103 miles of South Devon coastline, or for the adventurous to explore the entire South West peninsula, is on foot via the South West Coast Path. Superbly maintained and waymarked with the familiar acorn logo, the South West Coast Path is a continuous footpath that starts at Minehead in Somerset and follows the superb and varied coastline of the South West all the way to Poole on the Dorset coast. The path is considered by many to be one of the best long-distance walking trails in the world.

On its journey, the path rolls over the hills of Exmoor, clings to the rugged cliffs of North Cornwall, meanders through the South Devon Area of Outstanding Natural Beauty and passes the iconic landmarks of Lands End, St Michael's Mount and Durdle Door. Along the way, the path visits two World Heritage Sites, one National Park and five Areas of Outstanding Natural Beauty. It also traverses glorious beaches, bustling harbours, windswept headlands and secluded coves, and provides access to some of the most spectacular coastal views in Britain. The South West Coast Path is the longest long-distance footpath in England, spanning more than 630 miles from end to end and, thanks to the numerous steep river valleys and rolling clifftop paths, taking on the challenge of walking the whole path is arguably the equivalent of climbing Mount Everest four times.

Although the South West Coast Path only officially came into existence as a recognised trail in 1978, many of the footpaths that went into making it have been in use for centuries; some were created by smugglers and the battle with the Excise men to deny them their spoils. By the eighteenth century, it was estimated that as much as 50 per cent of all the spirits drunk in England had been smuggled into the country, resulting in a huge loss of duty to the Crown at a time when increasing tax revenues were needed to pay for the Napoleonic Wars. The crisis eventually led to the setting up of a National Coastguard Service in 1822, and was an attempt to thwart the smugglers by throwing a human cordon around the entire coastline of Britain.

In Devon, one coastguard was posted every half mile and was responsible for regularly patrolling that section of coast on foot. In order to minimise collusion between coastguards and smugglers, coastguards were posted far from their homes, which created a need for local accommodation. This led to the building of large numbers of coastguard cottages scattered along the coast, many of which can still be seen along the coastline of the South West today. As it was important for coastguards to see into every cove, the paths they created during their patrols tended to hug the coastline, leading to many of the well-trodden footpaths that would be used to create the South West Coast Path 150 years later.

Whether it's dog walkers or holidaymakers out for a short stroll, or long-distance hikers taking on the challenge of walking the whole trail, the South West Coast Path provides visitors with a fantastic way of exploring the heritage, geology, wildlife and stunning coastal scenery of the South West.

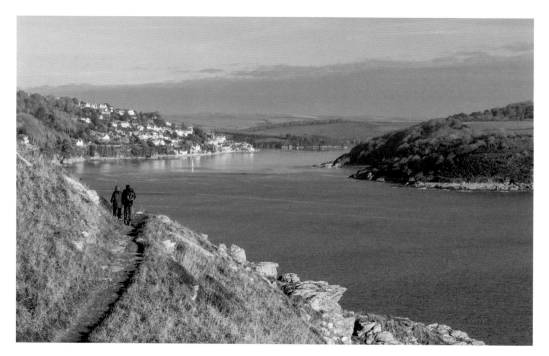

Walkers on the South West Coast Path as it heads for Salcombe.

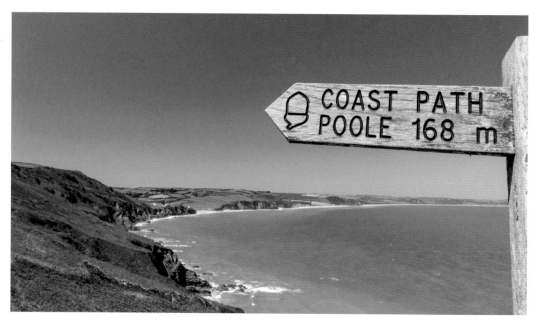

One of the many signposts on the well maintained South West Coast Path, overlooking Start Bay and informing weary walkers there are only 168 miles to go!

Early History

The Geology of Devon

Devon is internationally recognised for its hugely varied geology, which, as well as providing a unique insight into 400 million years of Earth's history, is fundamental to its natural beauty. Devon's rocks have been so instrumental in understanding our planet that the county has even given its name to a period in geological history. The Devonian period (between 359 and 416 million years ago) was named after the county after these ancient rocks were first studied here in 1838. The international significance of its geology was further recognised in 2007 when the English Riviera became the first urban Geopark, part of a European network created to promote a greater understanding of our natural world.

The story of its rocks is the earliest possible history of Devon: a story of how the very earth upon which we stand was created within ancient ocean sediments, drifting over unimaginable time-scales to where we see them today through the endless journey of the Earth's tectonic plates across the surface of our planet.

Under Tropical Seas

Devon's story began relatively recently in geological terms, only 400 million years ago, in the Devonian period. At the time, what was to become the land mass of Devon was located south of the equator under the shallow, tropical waters of the Rheic Ocean, where they lapped the shores of an ancient continent called Laurussia. Early life such as sponges and ammonites thrived in these warm waters, and their remains gradually accumulated on the sea floor. Over millions of years, these were buried and compressed by enormous geological forces to eventually form the Devonian limestone rocks that can be seen today around Berry Head and Hope's Nose. In deeper waters, ash from nearby volcanoes settled on the seabed to eventually form the Devonian shale and slates that can be seen today around Torquay at Thatcher Point and Meadfoot Beach.

Continental Collisions

By the Carboniferous period (around 300 million years ago), Devon's rocks were caught up in an enormous collision between the ancient continents of Laurussia and Gondwana. The collision led to the creation of Pangaea, a single super-continent that for millions of years contained all of the Earth's land mass. The collision also created a huge mountain chain called the Variscan Orogeny, stretching from present-day North America through Devon and onwards to Eastern Europe. The cataclysmic forces of the collision caused the Devonian rocks to be pushed up into the mountain chain, where huge geological forces stretched and folded them over millions of years. The results of these enormous forces can be clearly seen at many places along the coast today, including at Babbacombe, where layers of older Devonian rocks have been turned upside-down and now sit on top of younger slates.

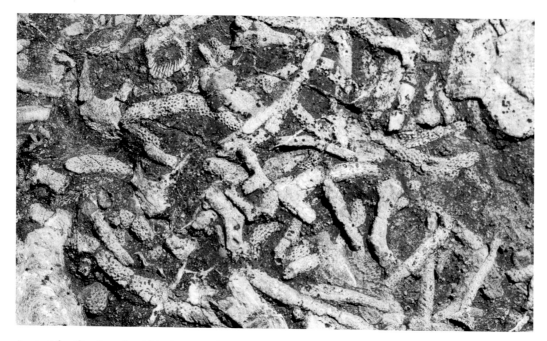

Ancient fossilised corals within Devonian limestone rocks at Meadfoot Beach, Torquay.

Vivid red Permian sandstones at Langstone Rock, Dawlish Warren.

Mountains and Deserts

By the Permian period (280 million years ago), Devon's land mass lay near the present-day Sahara desert in an arid part of the Pangaea super-continent as it drifted slowly north of the equator. The power of wind and weather would gradually erode the huge mountain chain, exposing the Devonian rocks buried within them. During dry periods, desert sands would pile up into ancient sand dunes, which, millions of years later, would become the classic red sandstone cliffs seen today around Dawlish, where the curving lines of ancient windblown dunes are still easily visible. During wetter periods, floods washed debris down from the mountains and into the desert plains, producing a mixture of desert sand and pebbles. This would form the Breccia rocks that can now be seen in many places around Dawlish and Torquay.

A Time of Extinctions

At the end of the Permian period, a mass extinction event wiped out 95 per cent of all life. However, it also provided an opportunity for dinosaurs to become dominant. Having first evolved during the late Triassic period (around 200 million years ago), dinosaurs thrived during the Jurassic period until they too were the victims of a mass extinction event, leaving only bones as evidence of their 150-million-year domination of life on Earth.

By the end of the Triassic period, sea levels rose and Devon's land mass was once again at the bottom of a tropical ocean. During the Jurassic period (around 150 million years ago), new layers of rock formed and a journey through this period of geological time can be found today along the Jurassic Coast. The enormous geological forces of later continental collisions created the majestic Alps and Himalaya mountain ranges, as well as creating a number of geological fault lines through the Devon land mass. The Babbacombe Cliff Railway is built along the Sticklepath fault, a fault line that runs between Bideford Bay and Torbay.

Raised beaches at Hope's Nose, left as sea levels fell 15,000 years ago.

The Arrival of Man

The Quaternary period (from 2.6 million years ago to today) saw the Devon land mass move to its current location, a number of major ice ages, and the arrival of modern man (*Homo sapiens*) from the African continent. At times, the amount of water trapped in ice sheets would cause sea levels to be much lower than today, and corridors of dry land would stretch from Devon to the near continent. This allowed alien species to cross into Devon from mainland Europe, where they would seek shelter in caves carved out of ancient limestone by the action of water over millennia. Evidence of some of these alien species, including sabre-tooth cats and cave bears, have been found in a number of South Devon's caves, where their bones lie side by side with those of some of our earliest human ancestors. At other times, the ice sheets retreated, pushing sea levels much higher than today. Evidence of these higher sea levels can be clearly seen around Torquay at Hope's Nose and Thatcher Rock, where ancient beaches lie stranded many metres above current sea level.

Much of the beauty of South Devon's coastline is down to the amazing history of its rocks. These rocks began life under tropical seas, before spending 400 million years gradually drifting northwards within ancient continents, mountains and deserts. They have been carved over millennia by the endless power of ice, water, wind and waves to produce the varied and stunning coastline that we see today.

Ancient Beginnings

Thousands of years before the ice sheets of the last ice age had retreated from Britain, and before the construction of Stonehenge, humans were already living in what would become the county of Devon. Finds in caves at Torquay, Brixham and Plymouth have provided amazing clues to the lives of some of our earliest ancestors. One find, a jawbone found in Kents Cavern in Torquay, is 44,000 years old, from a time when our earliest ancestors shared the lands of Devon with Neanderthals, woolly mammoths and cave bears.

The ancient Palaeolithic population of Devon was sparse, with no more than a few hundred hunter gatherers roaming through an empty landscape. By the Neolithic period (around 5000 BC), people started to turn from a nomadic hunter-gatherer lifestyle to a more settled existence of farming around permanent settlements. With this more sedentary lifestyle, evidence of our Neolithic ancestors becomes more plentiful and includes a number of burial chambers around the base of Dartmoor, where they began to respectfully bury their dead.

From the Bronze Age (2000 BC) right through to the Iron Age (600 BC), there was an explosion of human activity in Devon, as witnessed by a proliferation of evidence that they left behind. The remains of over 1,300 hut circles have been found around Dartmoor, especially around the upper valleys of the Erme, Yealm and Plym rivers, which suggest a proliferation of permanent Bronze Age settlements. There are also the remains of thousands of monuments on and around Dartmoor, including burial chambers, stone rows and standing stones. Similar monuments have been found in Brittany, leading to suggestions that the expanding Bronze Age population was caused by an influx of people from across the channel, perhaps encouraged by a welcome improvement in the wet and chilly British climate.

Evidence of early human activity on the South Devon coast is so important to our understanding of early British history that a number of historical periods are named after Devon locations, including the Mount Batten phase (a period in the late Bronze Age from 900 BC), which was named after the Mount Batten area of Plymouth. This was around the time that an ancient Bronze Age ship carrying a cargo of tin sank at the mouth of the River Erme, where it lay undiscovered for more than 3,000 years.

These early Celtic occupants of Devon were to become known as the Dumnonii tribe (meaning 'the people of the land'), who built over 100 hill forts in Devon during the late

Iron Age (including the one at Bolt Tail near Salcombe) and were to eventually give their name to the county of Devon. Their Iron Age tribal capital is thought to have been the fort at Hembury in East Devon; however, they had moved home to Exeter (originally called *Isca Dumnoniorum*) by the time the Romans invaded Britain in AD 43.

The Coming of the Romans

The invasion of Britain began under the Emperor Claudius in AD 43; however, it took forty-one years and a further seven emperors for the Roman army to complete the conquest. It was during some of the earliest campaigns that armies came west along the channel coast to the West Country, and finds at Topsham on the River Exe (later to become an important Roman naval port) suggest that the Romans had arrived by AD 54, soon after the start of the invasion. Since Britain had been known for its mineral wealth for many centuries, it is likely this was a key motive for the sustained Roman campaign to take control of the country, despite obvious resistance.

Exeter had been home to the Dumnonii tribe for centuries, but by AD 55 the town was held by the Romans. With a defensive fort overlooking the quay, it became the Romans' westernmost frontier town and a terminus of the great Roman road, the Fosse Way. The Romans stayed in Exeter for over 300 years, and remnants of the town walls they built in AD 200 to defend the city can still be seen today. Although there is some evidence of Roman activity west of the Exe, it is sparse and suggests that much of Devon remained largely free of Roman influence. However, this does not appear to be because the Dumnonii tribe were hostile to the Romans, as they continued to rule the lands of Devon and Cornwall (then known as *Dumnonia*) in an alliance with Rome.

Saxon Settlers

The Roman Empire began to falter late in the third century AD and the Romans finally left Britain in AD 410, leaving the country to return to its pre-Roman tribal government, including the Dumnonii, who continued to rule the lands of Devon and Cornwall. At that time, Devon was thinly populated and the landscape was still wild and untamed, consisting of high, barren moorland, boggy lowland and thick forests. However, the arrival of another invading force in the fifth century would bring an end to the rule of the Dumnonii tribe, as well as some of the most dramatic changes in Devon's long history. The invaders were the Anglo Saxons, a mixture of Angles, Saxons and Jutes from present-day Germany, Holland and southern Scandinavia, who began arriving in Britain soon after the departure of the Romans, eventually reaching Devon around the seventh century AD.

The new Saxon invaders won a major victory over the resident Britons at Penselwood on the Wiltshire border in AD 658, and by AD 710 the new Saxon Kings of Wessex and Sussex went on to attack King Geraint of Dumnonia. This finally brought to an end the rule of the ancient Dumnonii in Devon, although it took over 100 years more for them to be defeated in neighbouring Cornwall.

Devon was still sparsely populated, and it is likely that the Saxon invaders were largely able to settle the wide-open countryside without any opposition from the scattered Celtic communities. Over the centuries that followed, the Saxons went on to establish hundreds of new settlements across Devon, and many of these remain today, including Paignton, Dawlish and Brixham. Although the Celtic kingdom was defeated, the native Dumnonii people continued to live relatively peacefully alongside the Saxons, and the Celtic language they spoke is thought to have survived in parts of Devon until the Middle Ages.

In AD 936, the border between Devon and Cornwall was set at the River Tamar by King Æthelstan, and Devon finally became a shire of the Kingdom of England.

Viking Longships

The Vikings were infamous seafaring raiders and settlers from Scandinavia, and their iconic wooden longships took them across Europe and Asia from the eighth to the eleventh century. The Vikings became a major threat to peace in Saxon England when they began raiding English coastal communities around AD 835. The Anglo-Saxon Chronicles report of Viking forces being defeated by the people of Devon during one raid on Paignton in AD 851, and in AD 876 Vikings went on to capture Exeter, holding it for over a year before being evicted by King Alfred. The Danes once again tried to capture Exeter in AD 1001, but after failing to take the town they fought local forces at nearby Pinhoe and went on to raze the village to the ground.

Although eastern England saw widespread Viking settlement, Devon saw little of this and only briefly came under Danish rule in AD 1016. The Viking invaders chose to target Devon communities merely for plunder from their nearby base on Lundy Island (meaning 'Puffin Island' in the Old Norse language).

Norman Conquest

In AD 1066, a force of Norman, Breton and French soldiers, led by Duke William II of Normandy, landed on the South Coast, intent on taking the throne of England. King Harold confronted the Norman armies at the infamous Battle of Hastings, where the English were beaten, the King was killed, and the Norman Duke became William the Conqueror, ushering in the Norman period of British history. In AD 1085, William commissioned the Domesday Book, a document whose name would still be familiar almost a thousand years later. Domesday was an audit ordered by William in order to understand how much his newly conquered lands were worth, and although it was a massive undertaking, it was completed in just six months and still provides an amazing snapshot of early Norman England.

At the start of the Norman period, Devon was one of the most sparsely populated counties in England with a population of 70,000 people, less than that of Exeter today. At that time, Plymouth and Dartmouth were no more than small fishing settlements, and most of Devon's population lived in hamlets or isolated farms, relatively unchanged since ancient Celtic times. The population remained poor, living subsistence lifestyles with only small cottage industries such as pottery and cloth making, and the landscape around them still consisted largely of undeveloped woodland, bleak, high moorland and boggy lowland.

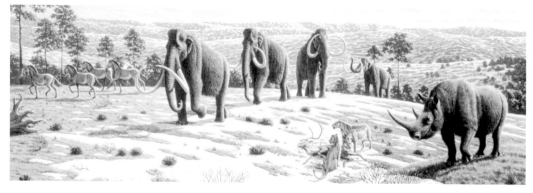

A depiction of a late Pleistocene Spanish landscape (between 125,000 and 11,000 years BC) including woolly mammoths and European cave lions. Low sea levels allowed Ice Age animals to cross to Britain, and their remains have been found within Kents Cavern.

Kents Cavern

Torquay is home to Kents Cavern, formed over 2.5 million years by rainwater slowly eroding the Devonian limestone rocks to leave a network of caves and passages. The caves are not only fascinating for their spectacular geology, but are also one of the oldest sites of human occupation ever discovered in Britain.

During the nineteenth century, early scientific study of rocks began to question the long-held religious belief that mankind had been created in 4004 BC. In 1825, Father MacErney, a Roman Catholic priest from Torre Abbey with an interest in archaeology, began excavating at Kents Cavern. MacErney discovered that man-made flint tools appeared in the same layers as the bones of long extinct animals, leading him to the astounding conclusion that mankind was far more ancient than previously believed. However, the revelation was so against widely held religious belief that his findings were largely ignored.

The remarkable story of Kents Cavern remained hidden until schoolteacher William Pengelly began his own excavations within the caves in 1865. He also found evidence of ancient human occupation alongside extinct animal remains, and went on to systematically excavate 80,000 specimens over the next fifteen years. Pengelly used the growth rate of stalagmites over ancient cave graffiti to provide solid dating evidence, and went on to prove that the caves had been occupied by extinct animals alongside our ancient human ancestors for over 500,000 years. By the late nineteenth century, Pengelly's work was still viewed as controversial, but the evidence he discovered within Kents Cavern was a major factor in the eventual acceptance of the truly ancient history of mankind.

The finds at Kents Cavern provide an amazing insight into life in South Devon, stretching far back into prehistory. A flint hand-axe left in the caves by Stone Age man, *Homo erectus,* over half a million years ago is the oldest man-made tool ever found in Britain, and a jawbone dated to 44,000 years ago is the oldest evidence of modern man ever found in north-west Europe. The caves have also provided evidence that modern humans and Neanderthals coexisted for many thousands of years, as well as showing us the range of ancient animals that used to roam the South Devon landscape, including cave bears, Ice Age hyenas and woolly mammoths.

Later History

Transforming the Devon Landscape

The Middle Ages saw enormous changes in the landscape of Devon. Many of the settlements that appear on modern maps came into existence during this period, largely due to a change in the way that the wealthy landowners, who owned much of the county, managed their lands. A move to granting charters to allow tenant farmers to lease and work the land led to the creation of thousands of new farms, as well as an extensive network of roads to connect the many new, isolated farming communities. The resulting explosion in agriculture led to the felling of much of the ancient Devon woodland, the draining of marshland and, ultimately, a Devon landscape that would be largely recognisable today. Landowners attempted to further grow their wealth by establishing new boroughs on their lands, as the taxes from the towns that they hoped to develop would be far greater than that possible from agricultural land. Although some failed to develop, at least seventy Devon towns have their origins in these medieval boroughs.

The Middle Ages also saw a number of new industries emerging, bringing new prosperity to the region. Dartmoor tin mining began to flourish, and new stannary towns, such as Plympton, began to thrive around processing the tin ores. A number of Devon towns, such as Honiton and Tiverton, began to prosper around the cloth industry, and Dartmouth and Plymouth became bustling trading ports and naval bases.

The growing prosperity of the Middle Ages was soon to be rudely interrupted by the arrival of terrible disease in the summer of 1348. The bubonic plague was carried by rats and fleas, but also spread easily through the air between its human victims. At a time when disease was little understood, the population had little idea of how to reduce the risk of contagion and plague soon became rampant. Victims died within a matter of days, suffering horrible symptoms, including vomiting blood and painful swellings called 'buboes', which were often black in colour and gave the disease its alternative name of 'the Black Death'. The impact on Devon was devastating, with 40 per cent of the population falling victim to the disease, rich and poor alike. The result was abandoned settlements, industry at a standstill, and a period of great hardship.

Tudor Prosperity

Despite occasional returns of the plague, the Tudor period saw a new period of prosperity for Devon. Thanks to a boom in farming, industry and seafaring, Devon was transformed from a poor frontier region to one of the richest counties in England. Farming expanded as more land was reclaimed and the cloth trade boomed, with Devon responsible for 10 per cent of all British cloth exports by 1500. The county's maritime role also flourished, with Devon becoming second only to London for the size of its merchant shipping fleet, as well as playing a central role in the Newfoundland cod trade. The boom in prosperity also led to a dramatic rise in population, transforming Devon from one of the most thinly-populated English counties in 1377, to the second most populated by 1570.

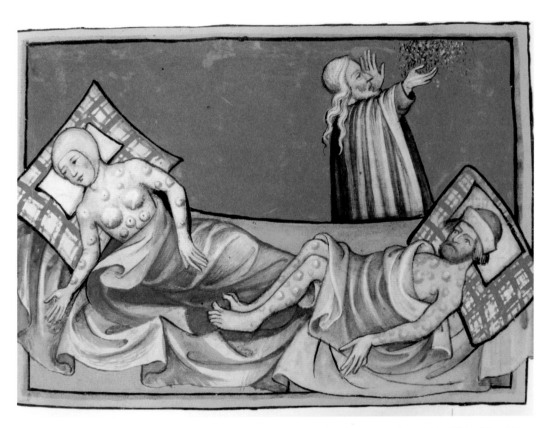

Above: A depiction of the bubonic plague from the Toggenburg Bible of 1411.

Right: Painting of Queen Elizabeth I from *c.* 1588, commemorating Britain's international power and the defeat of the Spanish Armada (shown in the background).

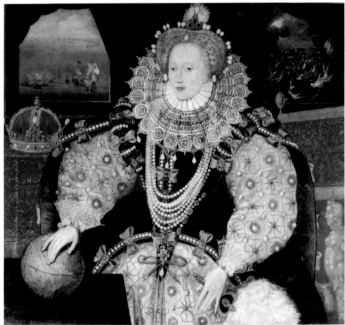

Devon was also home to some of the most influential Elizabethan mariners, such as Drake, Hawkins and Raleigh, who led an era of discovery and transformed Britain into an international sea power. Plymouth Hoe was the location where, in 1588, Sir Francis Drake famously finished his game of bowls before leading a war fleet to defeat the Spanish Armada.

Civil War

The seventeenth century was a time of religious and political unrest in England, including increasingly serious divisions between King Charles I and his Parliament. By 1642, these divisions led the country to armed conflict, with the onset of the English Civil War. Devon was a divided county during the war, with towns and cities largely Allied to Oliver Cromwell's Parliamentarian forces, and rural areas largely supporting the King's Royalists. The early stages of the war saw constant sieges, bloodshed and destruction, but a desire for peace soon led to a formal cessation of hostilities in Devon and Cornwall in 1643. However, small-scale skirmishes continued, and Dartmouth and Exeter were eventually captured for the Parliamentarians by Sir Thomas Fairfax in 1646. King Charles was taken prisoner in 1645 and, after an escape in 1647 and brief renewed hostilities, he was finally defeated, bringing an end to the war. The King was executed for high treason in 1649, with Oliver Cromwell's name on his death warrant.

Georgian Devon

With Britain at war with France for many of the years between 1689 and 1815, South Devon's ports played an increasingly important role in the defence of the nation, with a naval shipyard at Dartmouth and a new naval port at Devonport. Devon's merchant navy was also thriving, with over 700 registered ships, and one in five Devon men making their living from the sea in 1788. One of the benefits of the Napoleonic Wars was that they were the catalyst for the beginning of a new industry in Devon, and one that endures to the present day. With naval blockades often making continental travel impossible, wealthy travellers followed the example set by King George III and began holidaying on the South Devon coast, beginning the age of tourism.

During the eighteenth century, another of Devon's thriving industries was smuggling. With the government forced to impose ever more duties to pay for the endless wars with France, the demand for smuggled goods grew significantly and provided an unmissable opportunity for smugglers to thrive. Against a background of an increasingly poor population, the smuggling of luxury goods such as tea, brandy and tobacco became a way of life for many people, with networks of shippers, financiers and distributors developing at all levels of society. By 1783, it was estimated that half of England's smuggled brandy came in through Devon and Cornwall, amounting to a colossal 18 million litres per year, or six bottles for every English adult.

A Life of Smuggling

As long as there have been taxes on goods, there have been smugglers trying to avoid them, and the story of smuggling stretches a long way back into history. However, by the late eighteenth and early nineteenth centuries, what had traditionally been a small-scale local trade had exploded into a major industry and huge quantities of contraband were flooding into Britain. Devon's ports were at the centre of this industry, and the livelihood of many Devon residents became intimately linked to smuggling.

The boom in smuggling was the inevitable result of huge increases in customs and excise duties, which were applied to imported goods by successive governments struggling to pay for the endless wars with France. Duties increased steadily during the early eighteenth century, and were applied to more and more imported goods, putting an increasing number of everyday items outside the meagre means of ordinary people. Historically, import duties had been collected by customs men based at Britain's major ports, Although this system had worked well for centuries, it was ill-prepared for the explosion in smuggling that was to come. Some estimates suggest that at its peak in the late eighteenth century, as much as a quarter of all the goods imported into Britain were illegal, and for some items, such as tea, the figure was nearly two thirds. The coast of South Devon was perfect for smugglers, with its proximity to the main sources of contraband in the Channel Islands and France, its secluded beaches and coves, and the logistical problems of policing such a remote coastline.

Smuggling was viewed as completely acceptable by all levels of society. Smugglers were often seen as local heroes, as smuggling was the only way that most people could afford luxury goods such as tea and brandy. As a result, large numbers of South Devon communities were directly involved in smuggling, and those who were not involved were well practised at turning a blind eye. This made the Excise men's job virtually impossible, since few in the community were prepared to help them catch the culprits.

With smuggling more profitable than fishing, and despite the risk of death by hanging if caught, many skilled sailors turned to smuggling as a way of making a good living. They crammed their ships with smuggled goods, and used their seafaring skills to spirit them across the English Channel, often in bad weather and at night to increase the chances of evading the Excise men. Landing in secluded bays, they would be met by land-based smugglers, who would unload the boats and haul the goods up cliffs and through smugglers' tunnels to secret hiding places, ready for distribution. Even the gentry of society, including MPs, magistrates and clergymen, were known to have been involved as customers of smuggled goods, and sometimes even as the coordinators and funders of major smuggling operations.

Burgh Island was a major centre of smuggling, and was home to one of Devon's most notorious smugglers, Tom Crocker. After a lengthy career of successful smuggling and evading the authorities, Crocker was eventually apprehended and killed by the King's Excise men near the Pilchard Inn, his favourite haunt and the base for his smuggling activities. He is remembered to this day by giving his name to a cave on the island.

The enormous scale of smuggling eventually led to the establishment of a national coastguard service in 1822, which attempted to halt the smuggling and the huge loss of duties by throwing a human cordon around the entire British coastline. By the 1840s, the coastguard service, combined with the introduction of fairer levels of taxation, quickly brought the golden age of smuggling to an end. However, there are still plenty of reminders of the age of smuggling all along the South Devon coast. A narrow inlet at Holcombe near Teignmouth was a regular landing place for smugglers and, although their caves were destroyed by the building of the railway, the narrow lane leading to the secluded inlet is still called Smugglers Lane. At Maidencombe, there were tunnels leading from the sea up into the cellars of local houses, although there is obviously no proof that they were used for smuggling!

The Victorians

At the beginning of the Victorian era, horse-drawn coaches provided the main form of transportation and a network of coaching routes criss-crossed the county, dotted with inns to cater for weary travellers. However, a transport revolution began with Brunel's railway, which reached Plymouth by 1859, bringing affordable travel to ordinary people. Tourists began arriving in ever greater numbers and fuelled the development of many of South Devon's resorts, including an explosion in the population of Torquay by 1,750 per cent during the nineteenth century.

While the population of Devon's towns increased, the decline of traditional industries such as cloth-making, mining and agriculture prompted an exodus from the countryside. During the nineteenth century, 371,000 people left rural Devon, often heading for London and the New World, and many rural villages still have fewer inhabitants today than they did in the 1850s. Devon's cities also saw significant growth; Plymouth became one of Victorian England's most densely populated cities, with 209,000 inhabitants by 1914. Many came from famine-stricken Ireland, and from Cornwall and West Devon, where employment in traditional industries such as mining saw continuing decline.

The World Wars

Although the First World War was fought on the battlefields of France and Belgium rather than on Devon soil, the county was still hugely impacted by the loss of a generation of young men. More than 11,000 were killed during the war, most in the bloody trench warfare of the notorious battlefields of Ypres and the Somme. Their sacrifice is commemorated by the 2,000 memorials erected throughout Devon after the war, many of which still remain.

Although the First World War was fought overseas, the Second World War had a direct and devastating impact on Devon and its people between 1939 and 1945. The county became one of the most militarised in Britain, due to the need to defend its strategically important ports and military fleets, which were critical in helping to protect the Atlantic convoys supplying Britain with a million tons of vital supplies every week. As a result, Plymouth experienced some of the most devastating German air raids outside of London, and frequent bombing during 1941 destroyed many parts of the city beyond repair. Even smaller communities on the South Devon coast were not immune to this airborne destruction, with Brixham and Teignmouth both affected by low level 'tip and run' raids by the German Luftwaffe. Arguably, South Devon's most significant contribution the war came in its closing stages, when the area was used as a major training area to prepare troops for the D-Day landings, the beginning of the end of the Second World War.

The Coming of the Railways

The Great Western Railway (GWR) was one of the wonders of Victorian Britain, and had a huge impact on the South Devon coast when it arrived in the mid-nineteenth century. It began life in 1833 when Isambard Kingdom Brunel was appointed chief engineer to design a railway from Bristol to London. Although Brunel had no previous experience of railway construction, his design for the now iconic Clifton Suspension Bridge had already been accepted and he was fast becoming recognised as an innovative and accomplished engineer. The GWR project demanded that Brunel overcome immense engineering challenges, such as the construction of the 2-mile-long Box Tunnel between Bath and Chippenham. The longest tunnel in the world at the time, it took three years to complete and cost the lives of more than 100 navvies. Despite these huge challenges, the railway from London to Bristol opened in 1841.

Bristol merchants were keen to extend the rail link to Exeter, an important commercial centre near to South Devon's ports and a critical trade link to Europe. In 1836, an Act of

Row of Coastguard cottages on a remote stretch of coastline at Man Sands.

A smuggler's tunnel, linking the secluded Ness beach to Shaldon.

Parliament authorised the Bristol & Exeter Railway to build an extension south of Exeter, and Brunel was appointed as chief engineer. The extension was completed in 1844, along with the first train, consisting of six carriages and a steam engine called *Actaeon*. The train arrived in Exeter on 1 May after a five-hour journey from London, and was greeted by vast crowds, who had travelled from far and wide to see the latest wonder of modern science. By 1846, the line had been extended from Exeter to Newton Abbot, and by 1849 had reached Plymouth, linking much of South Devon directly to London. By 1865, the main line was extended into Cornwall, and Brunel completed another major engineering feat with the construction of the Royal Albert Bridge. In addition to the main line, branch lines were built to link it to a number of coastal towns, including Torquay, Paignton, Kingswear, Brixham and Exmouth.

Brunel's Atmospheric Caper

On Brunel's recommendation, the South Devon Railway was initially built using an experimental atmospheric system. Instead of powering locomotives using steam, the atmospheric system used stationary pumps to produce a vacuum within iron pipes along the centre of the track, and this was used to propel the trains. Brunel believed the system would be cleaner and quieter than conventional steam trains, and help them to climb the steep hills that would be encountered as the railway pushed deeper into Devon. The experiment ultimately turned out to be an expensive failure due to numerous technical problems, and in less than a year the trains were replaced by traditional steam engines. The last atmospheric train ran in 1848, but remnants of Brunel's project, nicknamed his 'atmospheric caper', can still be seen in the form of the Italianate pumping house at Starcross.

The South Devon Railway was built along the banks of the River Exe as far as Dawlish Warren, hugging the coast beneath the cliffs to Teignmouth, where it then travelled inland along the River Teign to Newton Abbot. A particularly impressive stretch runs along the sea wall for several miles between Dawlish Warren and Teignmouth, where the railway is wedged between the sea and dramatic red sandstone cliffs. As early as 1859, when the sea broke through defences at Teignmouth, there has been a constant battle to protect the exposed railway line from the power of the sea. After frequent landslips from the cliffs above and breaches by the sea below, several alternative inland diversions were considered in the 1930s. However, the outbreak of war meant that these plans came to nothing, and those maintaining the line continue their battle with the elements to this day.

The Growth of Tourism

The railways were instrumental in bringing affordable travel to ordinary people, and the tourists fuelled the developing tourist industry and the growth of many of South Devon's seaside resorts. Although most of the railways were constructed and run by small independent companies, they were gradually taken over by the GWR. By 1876, the GWR dominated the railways of South Devon, and this heralded the start of mass tourism and a boom time for South Devon's coastal resorts. As a sign of the importance of tourism to both the South West and to the GWR, in 1908 the GWR began promoting itself as 'the Holiday Line' through a series of posters and books. Although a number of South Devon's branch lines failed to survive Beeching's closures in the 1960s, the core of the rail network survived and continues to deliver holidaymakers to South Devon today.

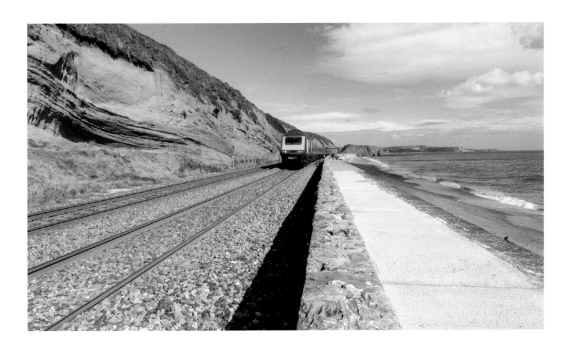

Above: Brunel's railway running between sandstone cliffs and the sea at Dawlish.

Right: Isambard Kingdom Brunel standing against the launching chains of his SS *Great Eastern* steam ship in 1857.

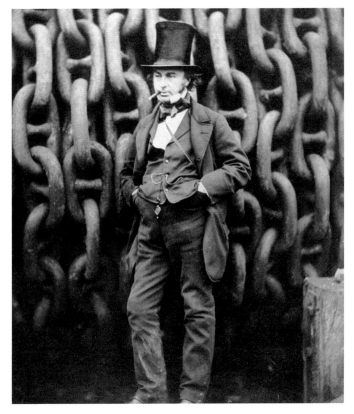

3

Exmouth to Dawlish

Exmouth

Exmouth is the first town on our journey along the South Devon Heritage Coast. As its name suggests, it sits overlooking the estuary of the River Exe, where it meets the waters of the English Channel. The town is the gateway to the Jurassic Coast World Heritage Site and boasts the longest seafront in Devon, with 2 miles of sea and river frontage, making it a popular destination for tourists since the eighteenth century. Exmouth is not thought to have ancient origins, probably due to its exposed location. However, the parishes of Littleham and Withycombe Raleigh, now part of the modern town, predate the seventh-century arrival of the Saxons in Devon.

The known history of Exmouth begins around the eleventh century, when it was known as *Lydwicnaesse,* meaning 'the point of the Bretons' (a reference to a sandspit that used to reach out into the estuary). The Strand area of present-day Exmouth is thought to have started as

Storm at sunset over Exmouth beach.

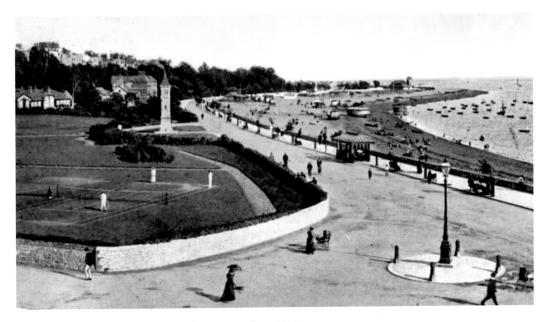

Early postcard of the Esplanade at Exmouth, *c.* 1905.

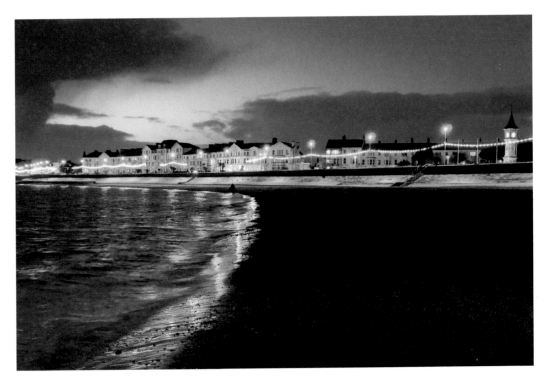

The Esplanade from Exmouth beach at sunset.

a cluster of buildings along the shore of this sandspit. The first port at Exmouth developed around 1240, when the area of the current ferry dock was sold to the mayor of Exeter. Then known as *Pratteshuthe* (meaning 'Pratt's landing place'), its shallow waters restricted the size of shipping, which stifled trade from the port and meant that by the thirteenth century Exmouth still consisted of little more than a small port, a windmill and a few farms.

The main growth of the town began in the eighteenth century, when it became a popular retreat for wealthy holidaymakers. Prevented from visiting the continent by the Napoleonic Wars, they began visiting Exmouth for its fine coastal views and medicinal salt waters, staying in the fashionable Georgian houses that began to spring up on the Beacon. One of these houses was occupied by Lady Frances Nelson, the estranged wife of Admiral Lord Nelson, famed for saving Britain from invasion by Napoleon's French armies. Lady Nelson moved to the Beacon in 1807, shortly after the Admiral was killed at the Battle of Trafalgar, and is buried at nearby Littleham church.

Exmouth has had other famous visitors during its history, including the iconic aristocrat and explorer Sir Walter Raleigh. Born in the nearby village of East Budleigh, Raleigh is reported to have departed from Exmouth on many of his voyages of discovery during the sixteenth century. More infamous visitors include Turkish pirates, who carried out raids on the town in the seventeenth century to capture locals to sell as North African slaves.

By the middle of the nineteenth century, transport links to the town were still poor and tourist numbers began to wane as the South Devon Railway on the other side of the Exe provided easier access to the tourist resorts of Torbay. However, by 1861, a branch line finally connected Exmouth to the mainline at Exeter, heralding a golden age for the town as a holiday destination.

A boat on the River Exe at Exmouth. The Exe, whose name is derived from the Celtic *Isca*, meaning 'water', has given its name to many settlements along its path through Devon to the sea, including Exeter and Exmouth. The river fuelled the growth and importance of Exeter in the medieval period, and the estuary now forms one of the South West's most important wildfowl reserves.

The Jurassic Coast

The Eastern end of Exmouth seafront is the gateway to 95 miles of coastline forming the Dorset and East Devon World Heritage Site (better known as the Jurassic Coast), which provides a unique insight into geological history. The entire length of the Jurassic Coast can be walked on foot as part of the South West Coast Path, and in doing so walkers travel through 185 million years of the Earth's history. The geology is unusual, since the layers of rock would have originally formed sequentially, one on top of the other, over geological time. However, massive earth movements 100 million years ago tilted the layers of rock to the east and exposed the layers in the west to erosion. This eventually produced the unique cross-section through geological time that can be seen along the spectacular coastline today.

The oldest rocks in the geological sequence can be seen at Orcombe Point. These Triassic rocks were created 250 million years ago when the land mass of Devon lay near the equator at the arid centre of the Pangaea super-continent. The sands of this ancient desert eventually formed the Triassic red sandstone that can now be seen at Orcombe Rocks. The Triassic period was critical for the development of life on Earth, with a mass extinction followed by the development of new species such as early dinosaurs. By the end of the Triassic, many of our familiar four-legged animals, such as frogs and crocodiles, had emerged, as well as some of the first mammals. Another extinction event at the end of the Triassic wiped out many species and allowed the dinosaurs to dominate life on Earth for the next 150 million years. The rocks of the Jurassic Coast contain fossils of some of the dinosaurs that swam in the seas that covered Devon during the Jurassic period, including marine reptiles such as Ichthyosaurs and Plesiosaurs.

Made of samples of the rocks found along the Jurassic Coast, the Geoneedle overlooks Exmouth, the start of our journey along the South Devon coast.

Starcross

The village of Starcross sits on the western banks of the River Exe, overlooking Exmouth. In 1820, records described it as a small hamlet, known for its cockles and oysters. Brunel's railway arrived in 1846 as the main line to London was extended south from Exeter along the banks of the Exe. An Italianate engine house sits overlooking the estuary and is the best remaining example of the pumping houses built to produce the vacuum to propel Brunel's atmospheric trains. His failed experiment is remembered in the name of the Atmospheric Railway pub, located opposite the railway station.

Dawlish Warren

Dawlish Warren is a small seaside resort, situated at the mouth of the River Exe and consisting almost entirely of holiday accommodation. Like the author, many will have memories of childhood holidays in one of the caravan parks, which add up to 15,000 tourists to the local population during the summer months.

Most of Dawlish Warren consists of a rare double sandspit formed by two dune ridges, once separated by a tidal creek (which was filled in during the 1940s). In geological terms, the sandspits are relatively young, having formed 7,000 years ago during the sea level rise that followed the last Ice Age. The sheltered area between the sandspits is now an important natural habitat for 600 flowering plant species, 20,000 migratory birds and is home to the rare sand crocus, found in only two places in Britain. As a result of its national importance, the spit was granted National Nature Reserve status in 2000.

Little is known of the history of Dawlish Warren (or 'The Warren', as it was known until the early twentieth century), although its name suggests that it may have been used to breed rabbits (for their fur and meat). During the mid-seventeenth century, a Civil War

The tower of Brunel's Italianate-styled pumping house at Starcross.

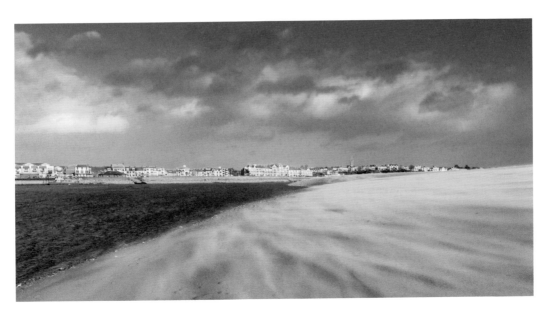

Drifting sands on Dawlish Warren back beach overlooking Exmouth.

fortification was constructed on the tip of The Warren. At the time of the Civil War, the sandspits were over 250 metres wide, but wind and waves have slowly eroded them and they are now less than 50 metres wide. Although work has been carried out to protect them with beach groynes and substantial sea walls, rising sea levels are likely to increase the threat to this delicate coastal landscape.

Although a few large houses were built on higher ground behind The Warren during the nineteenth century, the resort started to thrive with the arrival of the railways. Initially, a small station called 'Warren Halt' was built near Langstone Rock in 1905, later replaced by the current Dawlish Warren station. The increased ease of access provided by the railways, combined with increases in wealth and leisure time during the twentieth century, helped to develop Dawlish Warren into an increasingly popular destination for summer visitors.

Dawlish

The small seaside town of Dawlish sits between the Exe and Teign rivers, and has some of the finest Permian red sandstone cliffs found anywhere in Britain. The town's name is derived from a small river called Dawlish Water (also called The Brook), which still runs through the centre of the town. Early medieval documents from 1044 refer to a settlement called *Doflisc* (an Anglo-Saxon derivation meaning 'black stream'), and by 1468 the more recognisable name of *Dawlisshe* appears.

Even before there was a settlement at Dawlish, early Celtic settlers lived inland on higher ground where the land was fertile and not liable to flooding, but were frequent visitors to the coast to take advantage of its abundant natural resources. Fishermen would come to fish and salt makers built salterns, where seawater was evaporated to leave valuable salt. However, The Brook's tendency to flood during heavy rain eventually forced this early industry to move to Teignmouth, and salt making at Dawlish ceased in the early Anglo-Saxon period.

The current settlement of Dawlish is thought to have been founded by Saxon settlers soon after they reached Devon in the seventh century. Like most early coastal settlements,

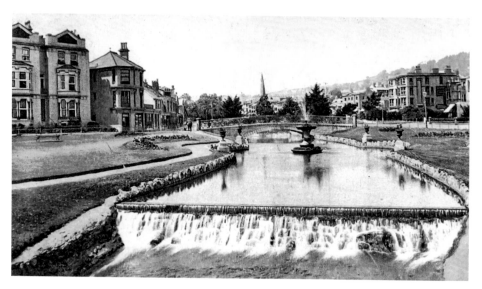

Postcard of The Brook and waterfalls, Dawlish, *c.* 1910.

the origins of Dawlish lie a mile inland, near to where the parish church of St Gregory stands today, well away from the ever-present dangers of storms and coastal raiders.

By 1044, records show that King Edward the Confessor gave the parish of Dawlish to Leofric, his chancellor, who went on to become the first Bishop of Exeter in 1050. By the time of Domesday in 1086, Dawlish was under the control of Bishop Osbern (Leofric's successor), who received a modest income from the 160 villagers who made a living from 100 sheep and lived in traditional cob (mud and straw) houses clustered around the church. As with many Devon settlements, the population was decimated by the bubonic plague when it swept through the village in the mid-fourteenth century, and three Dawlish vicars also lost their lives.

Little changed in Dawlish in the intervening centuries; however, the Industrial Revolution of the late eighteenth century heralded a period of significant change. A number of flour mills were built and Dawlish began to develop into a fashionable seaside resort as wealthy visitors started to arrive to take advantage of the therapeutic waters and sea air. By the early nineteenth century, the land between the early settlement and the sea had been extensively landscaped to cater for the influx of wealthy tourists. The Brook was straightened, waterfalls were added and fine houses began to develop on either side. This layout is largely unchanged to the present day, and relics of ancient Dawlish can still be found, including a house in Old Town Street, which clearly bears a date of 1539 above the door.

The railway brought a huge boost to the town when it arrived in 1846, making Dawlish the first seaside resort west of Weston-super-Mare to be connected by train. The line ran straight along the seafront, but Brunel carried the track over a small granite viaduct to maintain easy access to the beach. In 1906, a Dawlish-born New Zealander decided that the town needed an additional attraction and imported a number of black swans from New Zealand, which are still a common sight on the waters of The Brook today.

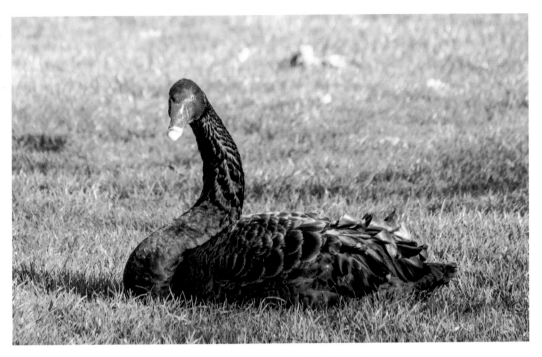

Black swans were introduced to Dawlish from New Zealand in 1906.

Dawlish seafront and Brunel's station at sunrise.

Teignmouth to Hope's Nose

Teignmouth

Saxon Beginnings

Teignmouth, a historic port located at the mouth of the River Teign, has been a popular destination for holidaymakers since the eighteenth century. The town is thought to have ancient origins, with native Celtic people making the high ground around the Teign their home for centuries before the Roman invasion. By the seventh century AD, Saxon invaders arrived and are thought to have formed the first settlement on the coast at Teignmouth. However, it was the Saxon Charter of 1044 that first recorded the settlement as *Tegne-mutha* (meaning the 'mouth of the stream').

Modern-day Teignmouth is created from the two villages of East and West Teignmouth, separated by a stream called the Tame, which still joins the river near the quay but is now hidden below ground. Although neither village was recorded by Domesday, and they did not appear on sixteenth-century maps, by the thirteenth century both were of sufficient importance to be granted market status.

Medieval Remains

Teignmouth has two churches with medieval origins, St James' in West Teignmouth and St Michael's in East Teignmouth. The original church on the site of St James' was dedicated in 1236 and the surviving sandstone medieval tower is probably the oldest remaining building in the town. There was a church on the prominent seafront site of St Michael's from the time of the Saxons; however, little remains of the original structure. Despite the damage inflicted by German air raids during the Second World War, much of the fine late Georgian and early Victorian architecture built during the town's development as a tourist resort still remains. Some of the best remaining examples include Den Crescent, the Assembly Rooms (built in the 1820s), and the fine Georgian buildings of Northumberland Street and Teign Street.

Conflict and Invasion

Despite its modest size, Teignmouth has seen more than its fair share of conflict. In AD 927, there was a battle on nearby Haldon Hill between King Howeland and Saxon forces, where the Celtic King was defeated and Devon was claimed by the Saxons. There were Viking raids in AD 1001, and the town was largely destroyed in 1340 by the French Navy during the Hundred Years War. In 1690, it gained notoriety as the last place in England to be invaded by a foreign power when, during the Nine Years War with France, the French fleet came ashore to attack the town. The residents sensibly fled, leaving much of West Teignmouth to be destroyed by fire, and the Jolly Sailor pub was the only building left standing on the quay. One of the streets rebuilt after the invasion was named French Street in commemoration of the event, and some of the canonballs from the attack can be seen embedded in a wall.

Ships and Trade

A port has existed at Teignmouth since at least the thirteenth century, and by the fourteenth century it was second only to Dartmouth in terms of local importance. The opening of the nearby Stover Canal in 1792 provided a boost to the port, allowing ball clay (used in the manufacture of ceramics) to be moved from the mines near Newton Abbot and on to ships for export. By the 1820s, trade was further boosted by handling granite from the quarries of Dartmoor, with the stone used to build the new London Bridge, opened in 1831, coming via this route.

Shipbuilding was a major industry for Teignmouth for many centuries, with the town providing eight ships to help King Edward defend England from invasion by French forces in 1326. There was a peak in shipbuilding during the 1850s, with three shipyards at Teignmouth and three more across the river at Shaldon and Ringmore. Railway sidings were constructed from the port to the new mainline to London in 1851, providing a quick way for goods to reach London. When winds in the Channel were unfavourable, large numbers of ships would offload mail, passengers and goods at Teignmouth for transfer to the railway.

By the seventeenth century, one of the town's most important industries was exploiting the fisheries of the Newfoundland coast of North America. Originally discovered by the explorer John Cabot during his voyages of discovery in 1497, the fish stocks were initially so plentiful that fishermen reported shoals of cod so thick that they were hardly able to row a boat through them. As news of this bounty spread, significant numbers of South Devon fishermen started to make a treacherous annual journey across the Atlantic to the fisheries of the 'New Found Land'.

Towards Tourism

Fortunately for the prosperity of the town, just as some of the traditional Teignmouth industries declined in the eighteenth century, tourism began to develop. By 1787, the Den area of the seafront had begun a transformation from a place where sheep grazed to one where tourist teahouses nestled among fishermen's nets. By 1821, early tourist guides were describing the town as a 'fashionable watering place', which included donkey rides, pleasure boats and bathing machines. By the nineteenth century, bathing machines had become a regular sight on many of South Devon's tourist beaches, where they were essential protection for the modesty of

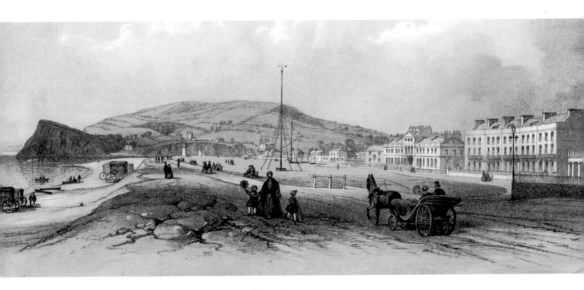

Teignmouth seafront and the Den around 1840.

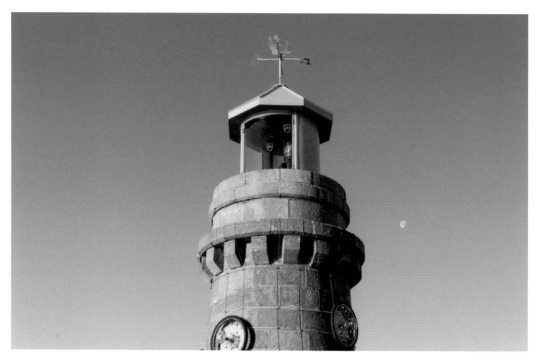

The tiny but fully functional Teignmouth lighthouse.

well-heeled visitors. Bathers would undress in the privacy of the machine before being wheeled into the sea, where they could slip discreetly into the water without being seen by other bathers.

Devon Cream Teas

A staple of holiday teatimes, the Devon cream tea is a combination of scones, clotted cream and jam that has been enjoyed by the people of the South West for centuries. There is some dispute about the history of the cream tea, with Cornwall, Dorset and Somerset all laying claim to its invention, however, the earliest written evidence of the teatime treat is said to come from Devon. It is alleged that manuscripts from the Benedictine Abbey at Tavistock describe monks feeding bread, clotted cream and jam to workers at the abbey in the eleventh century, and that this is the origin of the cream tea. However, even this is disputed, since all of the reports appear to lead back to a single unsubstantiated article.

This is not the only dispute associated with the humble cream tea, with regional disagreements about how it should be served. The Devon method is to split the scone, covering each half with cream followed by strawberry jam. Whatever the true history of the Devon cream tea, it undoubtedly has ancient origins, with clotted cream arriving in Cornwall with Phoenician traders as early as 500 BC. The Devon cream tea has survived over a thousand years to be enjoyed in tea shops to the present day.

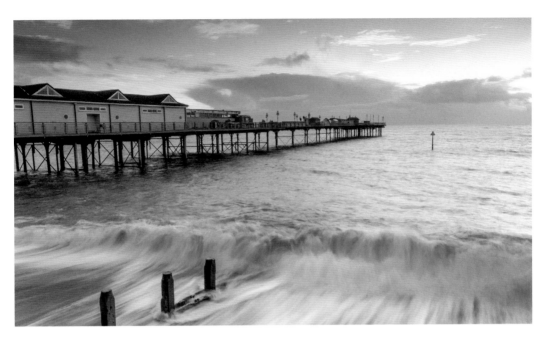

Winter sunrise over Teignmouth pier.

Crossing the Teign

Despite there now being a bridge across the Teign, the Teignmouth to Shaldon ferry is still a regular part of life on the river and may be the oldest remaining passenger ferry in England. A ferry can be traced as far back as 1296, but is probably much more ancient, perhaps with Saxon origins. During the Napoleonic Wars, black-and-white gun ports were painted on the ferries to make them appear fearsome to potential attackers. This tradition continued right through to the motorised ferries of the early twentieth century.

There is evidence of an ancient wooden bridge across the mouth of the Teign between Teignmouth and Shaldon dating to Roman times; however, the first modern bridge was built by the Shaldon Bridge Company in 1827. Costing £19,000, it was built from wood, had a toll house at each end (one of which still remains), and a swing bridge to allow tall-masted ships to travel through. Unfortunately, after only eleven years, the centre of the bridge collapsed and was found to be riddled with shipworm. By 1840, a new stone bridge had been built, and this remained largely unchanged until the twentieth century, when the major change in traffic from horse and wagon to lorries and buses meant that major strengthening and widening was necessary.

Piers and Lighthouses

As Teignmouth began to flourish as a tourist resort during the early nineteenth century, plans were drawn up for the construction of a pier, considered essential for any serious Victorian seaside town. The pier was a simple timber promenade deck supported by a framework of cast-iron piles, and was completed in 1867. Having been constructed in the centre of the beach, the pier soon acted as a convenient dividing line for bathers, with gentlemen to the west and ladies to the east. As with many British seaside piers, Teignmouth Pier has had its fair share of mishaps, with the entrance kiosks collapsing in 1904, the Castle

Pavilion destroyed by fire, and the jetty removed during the war to prevent it being used as a landing stage by German troops. Teignmouth is lucky to have retained its pier, with more than half of Victorian seaside piers disappearing since the turn of the twentieth century, and it is one of only two remaining in Devon that can still be visited today (the other being at nearby Paignton).

In the early nineteenth century, the port of Teignmouth was prospering with the export of china-clay and granite. These were heavy cargoes requiring larger vessels, which were increasingly prone to the dangerous currents of the Teign estuary. A lighthouse was constructed in 1845 to help guide them safely into the port. There were some unkind comments about the tiny lighthouse, including one that 'the feeble glare emitted from the lantern is of no service by night, except to light the fishes to their sandy beds.' However, despite often being mistaken for a toy, the small lighthouse still performs its task of guiding ships safely into the estuary.

The Parson and Clerk Rocks between Dawlish and Teignmouth. The rocks were named after a local nineteenth-century legend of a parson and his clerk who lost their way in the mist while visiting the Bishop of Exeter. The legend says that the Devil turned them to stone as punishment for the parson's ambition to steal the bishop's job, and the parson and his clerk now remain in the form of two sandstone stacks.

Shaldon and Ringmore

The scenic village of Shaldon sits opposite Teignmouth on the western banks of the River Teign, sheltered from the prevailing winds by the high sandstone cliffs of the Ness. Its name is a derivation of *nez* (Celtic for 'nose'), and it is said to be the site of an ancient battle between the Celts and the Saxons.

The earliest settlement on the Shaldon side of the Teign estuary was upstream at Ringmore (its name is a derivation of 'a great enclosure'), where there was greater shelter from storms and the land was more amenable to agriculture. Right up to the early twentieth century, Ringmore was the site of large cider orchards and beds of withy, a traditional material used to make lobster pots.

While Ringmore's St Nicholas church was established in Saxon times, the first written evidence of a settlement at Shaldon is not until the reign of King James I in the early seventeenth century. At this date, Shaldon is likely to have been no more than a cluster of fishermen's huts, and the earliest buildings remaining today are largely from the late seventeenth century. As with the Den at Teignmouth, the Green at Shaldon was originally sandy foreshore, and much of the village developed using land reclaimed from the river. On a map of 1741, the only building in this exposed part of the village was the Horse Ferry Inn, where traders would traditionally wait to cross the Teign, which could be forded at low tide.

The early history of Shaldon revolved around the sea, and the majority of the seventeenth- and eighteenth-century population were involved in the fishing industry, both catching

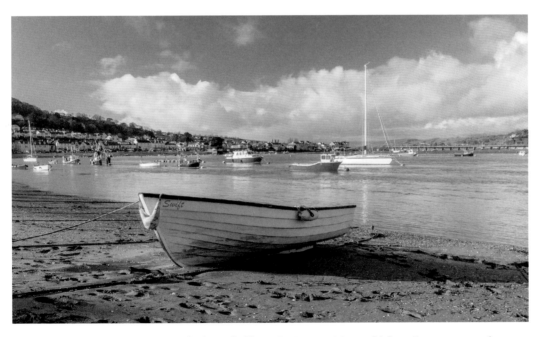

A boat on the River Teign overlooking Shaldon. The Teign originates high on Dartmoor near the ancient, prehistoric settlement of Kestor, before flowing down the eastern side of the moor to join the English Channel between Teignmouth and Shaldon. For centuries, the river was used to transport goods to the port at Teignmouth, but is now one of South Devon's most beautiful river valleys and home to an array of wildlife, including wild salmon, white egrets, and shell ducks.

locally and processing those brought back annually from the Newfoundland fisheries. A smugglers' tunnel at Ness Cove suggests that, as with many coastal settlements at the time, smuggling was also a major part of the local economy. Shaldon went on to develop a thriving industry in boatbuilding, with several of the ships involved in the Napoleonic Wars built on the shores of the Teign. Many of its fishing vessels were also built locally.

By the nineteenth century, the channel on the Shaldon side of the estuary had begun to silt up, and the focus of industry moved to Teignmouth. It was at this time that the village started to become fashionable as a holiday resort, and the many fine Georgian and Victorian houses within the village mark this move towards tourism. Shaldon remains an attractive village, with fishermen's cottages tightly packed along narrow winding streets, and is home to one of the oldest regattas in England, established in 1817 and still held in the village every August.

The impressive coastline around Torquay includes the promontory of Hope's Nose, with Thatcher Rock some way offshore. Made of Devonian limestone formed 400 million years ago, the ancient story of these rocks can be seen in the fossilised corals, trilobites and bivalves within them, laid down in the sediments of ancient tropical seas.

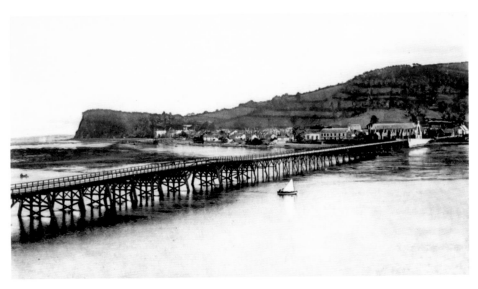

An early image of Shaldon bridge with Shaldon in the background.

One of many imaginative South West Coast Path markers along the 630-mile path.

5

Torquay to Berry Head

Torquay

Ancient Origins

Sitting on the coast overlooking Torbay is Torquay, the best known and largest of the seaside resorts along the South Devon coast. As with Brixham across the bay, there is evidence of truly ancient human activity around Torquay, with a flint hand-axe found in the caves of Kents Cavern providing evidence of Stone Age man sheltering there half a million years ago. The caves also provide evidence of some of the long-extinct animals that once roamed Torbay, including the bones of woolly mammoths. From more recent history, there is local evidence of Iron Age activity with the fort at Walls Hill, where ancient tribes would retreat in times of danger, and evidence of Roman visitors, who left offerings in Kents Cavern.

As with most coastal settlements, the origins of Torquay lie a mile or so inland, with a small village founded by seventh-century Saxon settlers. By Norman times, the village was known as *Tor Mohun*, named after its Norman owners and the craggy tor (hill), which is still visible between St Efride's Road and Tor Hill Road. By the sixteenth century and the reign of Henry VIII, the more recognisable name of *Torre Key* was in use. The 'Key' was a reference to the small waterfront quay surrounded by fishermen's cottages and alehouses, which had developed through the Middle Ages.

Modern Torquay is a grouping of several ancient parishes, and the way that Torquay developed was partly a result of the rivalry and aspirations of the family owners of those parishes. The Cary family owned Babbacombe and St Marychurch; Tor Mohun (central Torquay) was owned by the Palks and the Mallocks were the owners of Cockington. Unlike the Palks and the Carys, the Mallock family largely resisted the development of their lands and Cockington remains a picturesque village of thatched cottages clustered around the sixteenth-century Cockington Court, in stark contrast to the remainder of modern-day Torquay.

The Abbey, Drake and the Spanish Barn

Torre Abbey is the oldest building in Torbay and the most complete surviving medieval monastery in Devon. It was founded in 1196 by canons from Welbeck Abbey in Nottinghamshire, who were given the land by the Lord of Torre Manor, William de Brewer. The canons were from the Premonstratensian Roman Catholic order (also known as 'white canons' because of the colour of their habits) and by the end of the fifteenth century they had developed Torre Abbey into the wealthiest Premonstratensian monastery in England, earning the enormous sum of £1.8 million per year. This vast wealth enabled them to build Torquay's first harbour, and they later gained a charter from the King to develop the nearby market town of Newton Abbot in order to sell the produce from their extensive lands.

Following Henry VIII's dissolution of the monasteries in 1539, the Abbey church was demolished and the remaining buildings became a private house. Nevertheless, parts of the

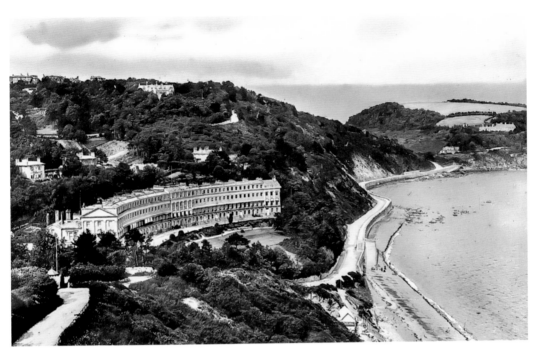

An early image of Hesketh Crescent, described as 'the finest crescent of houses in the West of England' in 1848.

The medieval Spanish Barn, used by Sir Francis Drake in 1588 to imprison captured sailors from the Spanish Armada.

original monastic buildings remain, including the twelfth-century entrance to the chapter house, and the Mohun gateway, which dates from 1320. Another ancient building is the medieval Spanish Barn, built as the Abbey's tithe barn around 1200 to hold taxes paid in the form of grain and farm produce. The barn gained its distinctive name from the role it played during the invasion of the Spanish Armada in 1588, when Sir Francis Drake used the barn to imprison captured prisoners from the Spanish ship *Nuestra Señora del Rosario*.

Royal Visitors and the GWR

Torquay remained a modest fishing and agricultural settlement until the early nineteenth century, when the town began to develop into a fashionable 'watering place', a Victorian term for a seaside resort. Tourism came rather later to Torquay than other South Devon resorts, largely because its terrain made it virtually inaccessible by land. A small Victorian toll house at the base of the cliffs at the east end of Abbey Sands is a reminder of a key moment in Torquay's history, marking a new toll road around the base of the cliffs, which was completed in 1842 and finally provided easy access to the resort.

Torquay's growth as a holiday destination was helped greatly by the Napoleonic Wars. Naval officers stationed nearby chose to meet their families there, and wealthy travellers, unable to travel to their usual European holiday destinations, began arriving in increasing numbers. The resort was also a favoured retreat for wealthy consumption (tuberculosis) sufferers, who found that the warm climate of Torbay eased their symptoms.

Following his defeat at the Battle of Waterloo in 1815, Napoleon Bonaparte became an instant tourist attraction when he was held as a prisoner on a ship anchored off the Orestone. As Torquay's fame spread, the cream of Victorian aristocracy and gentry began to visit, and

The remains of the ancient Torre Abbey, founded in 1196.

after Princess Victoria stayed in 1833, the town became the most popular destination for the upper classes. Its development as a tourist destination was further boosted by the arrival of Brunel's railway at Torre in 1848, later extended to Torquay in 1852. The enormous growth of the town in the first half of the nineteenth century can be seen from the growth in its population, which increased more than tenfold from 838 in 1801 to 11,474 by 1851.

Villas and Palms

One of the driving forces behind the development of Torquay during the nineteenth century was local banker William Kitson. As estate manager for the Palk family, Kitson was responsible for introducing a number of amenities that were behind the continued success of the town, including roads, street lighting and mains water. Kitson also devised plans for exclusive new residential areas, selling off land to wealthy clients to build lavish villas, including Hesketh Crescent, which, when it was completed in 1848, was described as 'the finest crescent of houses in the West of England'. The wealthy newcomers were also responsible for the Mediterranean feel of Torquay, through the Italianate features of their villas and the introduction of the 'Torbay Palm' from New Zealand in the 1820s, which remains a notable feature of the town. By 1864, the *Western Morning News* was describing Torquay as 'the most opulent, the handsomest and the most fashionable watering place in the British Isles.'

By the late nineteenth century, the wealthy winter visitors that the resort historically catered for once again began to holiday abroad, and by 1902 adverts started appearing to try and market Torquay to a new breed of summer tourists. Visitor numbers steadily increased, and an advertising campaign by the GWR successfully built Torquay as a popular summer resort, which it remains to the present day.

A Time of War

During the First World War, Torquay was used extensively as a base for injured soldiers, with many survivors from the Battle of Gallipoli sent to military hospitals in the town to recuperate. During the Second World War, Torquay was considered to be a safe location and became home to many evacuees from London; however, the town did suffer some damage from German bombers discarding unused bombs after raids on Plymouth. In the run-up to the D-Day landings of June 1944, thousands of US troops were billeted in and around Torquay, and during Operation Overlord 23,000 US Army troops left from landing stages around the town destined for Utah Beach.

The Queen of Crime

One of Torquay's most famous residents was the crime author Dame Agatha Christie. Born in 1890, Christie was christened in All Saints church at Torre and spent much of her childhood in and around the town. She maintained a close relationship with Torquay throughout her life, including setting some of her stories in the town. In a writing career that spanned half a century, she wrote more than eighty books, and her iconic crime novels have sold over 2 billion copies worldwide, making her the bestselling author of all time. The Agatha Christie Mile in Torquay commemorates some of the places that link her to the town.

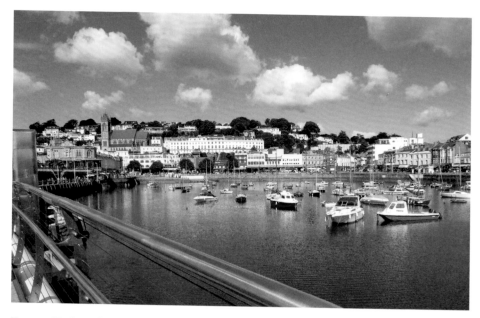

Torquay Harbour from the harbour bridge.

The picturesque Cockington Court, built on the remains of an ancient medieval court. The scenic village of Cockington was founded during the Iron Age and, despite its proximity to Torquay, retains its small village charm, with sixteenth-century thatched cottages and an eleventh-century church.

Paignton

Earliest Origins

The earliest history of Paignton can be seen in the red sands of its beaches and its distinctive sandstone cliffs. These are both evidence of ancient sand dunes, from a time 280 million years ago when Devon was a desert at the centre of an ancient continent as it drifted slowly north. At Royal Terrace Gardens, the jumbled cliff face is evidence of a geological fault line called the Sticklepath Fault, caused by the same dramatic movements of the Earth's tectonic plates that led to the formation of the Alps.

Although evidence of prehistoric and Roman activity has been found in and around Paignton, the earliest known settlement dates from the arrival of the Anglo Saxons in the seventh century AD. As with most coastal settlements, the small settlement of *Paega's Tun* was situated some way inland, around the area of present-day Church Street, Winner Street and Kirkham Street. The current layout of these streets is likely to match the original medieval layout, with Winner Street as the main street of the earliest settlement.

Rising Fortunes

By the Norman Conquest of the eleventh century, the manor of Paignton belonged to the bishops of Exeter. In the Domesday records of 1086, the settlement (by then known as *Peintone*) was a small agricultural community with fifty-two villagers, forty smallholders, five pig-men and thirty-six slaves scattered across the bishops' manorial lands. With over 700 acres of meadows, pastures, arable land, woodland, fisheries, vineyards and a market, Paignton was already a thriving community at a time when nearby Torquay had only just begun to develop.

Paignton's fortunes rose with those of the bishops of Exeter and it soon developed into one of their wealthiest manors, second only to that of Crediton. Its growing prosperity can

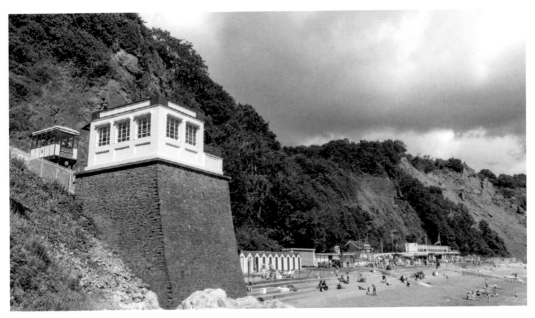

Behind Oddicombe beach is the distinctive Babbacombe Cliff Railway. Built in 1926 to take advantage of a natural geological fault line, it is one of only sixteen funicular railways still operating in the UK.

be seen by the town being granted borough status, a weekly market and an annual fair by King Edward I in 1295. Paignton also benefited from relatively advanced infrastructure for the time, such as culverts to bring in water to supply the Bishop's Palace and a manorial corn mill. This medieval water system remained the primary water source for the town all the way through to the late nineteenth century.

Buildings and Bibles

Some of the oldest Paignton buildings include the twelfth-century parish church of St John, which itself is likely to have been built on the site of an earlier Saxon church. The remains of the fourteenth-century Bishop's Palace can still be seen near the church and is one of nine manorial houses owned by the prosperous bishops. The Bishop's Tower adjacent to the church was built to defend the palace against Viking attacks, and is also known as the Coverdale Tower, as local folklore claims that the Bible was first translated into English there in the mid-sixteenth century by Miles Coverdale, one of the bishops of Exeter. The medieval Kirkham House, near the centre of the town, is a traditional house of a high status merchant family, dating from the late fourteenth or early fifteenth century, and has been restored by English Heritage to its original layout.

The Coverdale Tower, built in the fourteenth century to defend the Bishop's Palace from Viking attacks.

Cabbages and Railways

Manorial documents show that the town suffered a serious decline during the seventeenth and eighteenth centuries, with one observer travelling through Devon in 1750 describing Paignton as 'a poor town of farmers at the bottom of the bay.' By the beginning of the nineteenth century, it was still largely a farming and fishing community and was also renowned for its cider, huge quantities of which were shipped to London. It was also famous for its cabbages, particularly a variety called the Paignton Flat-poll, which was exported far and wide, and resulted in the locals being nicknamed 'Flat-polls' in honour of their famous vegetable.

During the early nineteenth century, the town began a steady transformation from a poor fishing and farming community to a family holiday destination, largely thanks to the economic impact of the naval fleets that regularly visited Torbay. By the 1850s, the development of Paignton as a seaside resort was well under way, with one publication describing the town as 'a neat and improving village and bathing place delightfully situated along the shore of a beautiful bay.'

The development into a tourist resort accelerated with the arrival of the Dartmouth & Torbay Railway in 1859. Such was the importance of the arrival of the railway to the town that on 2 August a huge civic celebration took place to greet its arrival, with a crowd of 18,000 people and the baking of a traditional Paignton pudding, which weighed a colossal 1.5 tons. A traditional feature of Paignton civic ceremonies since the thirteenth century, Paignton puddings were also baked in 1968 to celebrate the town's charter, and in 2006 to mark the 200th anniversary of the birth of Isambard Kingdom Brunel. Although the line onwards from Paignton was closed during Beeching's cuts in the 1960s, it still operates as a heritage line, with steam trains running regularly between Paignton and Kingswear (for Dartmouth) during the summer months.

The Father of Paignton

A critical part of the success of any Victorian seaside resort was the quality of its seafront and promenade. The development of Paignton's seafront began in 1867 when a local landowner gave an area of seafront sand dunes to the town, and local architect George Soudon Bridgman was employed to design a stylish sea wall and promenade. Soon an area of salt marsh behind the promenade was transformed into Paignton Green, where holidaymakers began to mingle with the sheep that had grazing rights through to 1908, and handsome Victorian terraces began to spring up as Paignton quickly developed into an elegant Victorian seaside resort.

Bridgman continued to play a critical role in the development of the town, including building Paignton Pier, the centrepiece of any Victorian seaside experience, which was opened in 1879. Bridgman became so instrumental to the success of the town that he soon became known as 'the Father of Paignton'. By 1891, the population of the town had reached 6,000 and marshland at Preston and Goodrington had been transformed into pleasure grounds and beaches, with the combined resort earning the nickname of 'The Town of Golden Sands'.

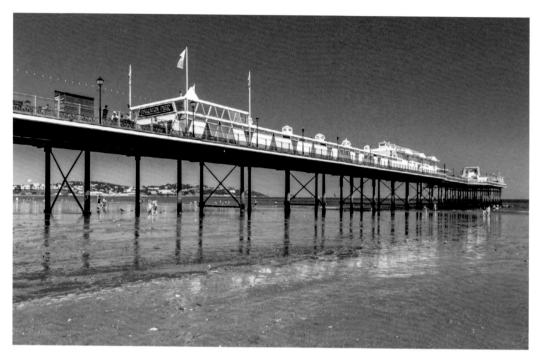

The pier at Paignton, opened in 1879 and the centrepiece of any fine Victorian resort.

Beach huts at Goodrington Sands, Paignton.

A steam train on the heritage railway between Paignton and Kingswear. The line uses the route of the original Dartmouth and Torbay branch line, which opened in 1864. Behind Broadsands beach, the railway crosses the majestic Broadsands viaduct, built to a classic Isambard Kingdom Brunel design.

The beautiful and secluded Elberry Cove was one of Agatha Christie's favourite bathing spots. It is also home to Lord Churston's bath house. Originally thought to be a Pilchard smoking house, it was later converted so that local Lord Churston and his guests could enter the sea to swim in privacy.

Brixham

A Palaeolithic Past

Brixham's caves have provided evidence of truly ancient human occupation. Finds within Windmill Hill Cavern have provided evidence of Palaeolithic man using the limestone caves for shelter between 250,000 and 40,000 years ago, and artefacts from the Bronze Age suggest that Brixham may also have been an early trading centre. As with the other towns on our journey along the South Devon coast, the present-day settlement has its origins firmly in Saxon times, with settlers first arriving on the coast at Brixham around the seventh century AD. The original Saxon settlement was inland around the site of the parish church of St Mary, and was part of a royal estate, as shown by the pre-conquest names of Kingswear and Kingston a little further inland.

The first written records of Brixham were in the Domesday audit of 1086, when the settlement was recorded as *Briseham*. By 1285, the name had evolved into *Birkkesham*, and eventually Brixham, a name derived from the Celtic family name *Brioc* and the old English *ham* (meaning 'the homestead of Brioc'). During the medieval period, two separate settlements began to develop: Higher Brixham, also known as 'Cowtown', was populated by Brixham's farmers; and Lower Brixham, or 'Fishtown', was home to a small community of fishermen. It was not until 1894 that the two settlements were merged to become the single town of Brixham.

Ancient Churches

All Saints church is a prominent building sitting majestically above the town. Home to Revd Francis Lyte, composer of the hymn 'Abide with Me', the current church stands on an ancient Celtic burial ground. The site was later reused for a succession of churches, including a wooden Saxon structure, a Norman stone building, and a medieval replacement in the fourteenth century.

Brixham also has numerous old cottages. Originally inhabited by the town's many fishing families, they line narrow, winding streets, which cling to the steep hillside above the scenic harbour. One of the most distinctive buildings in the town is the Coffin House, so called due to folklore, which tells the story of a local father who claimed that he would sooner see his daughter in a coffin than see her married. His plan was foiled by a creative suitor, who purchased the odd-shaped house, calling it 'the Coffin House' as a ploy to persuade the father to relent and agree to the marriage.

The Growth of Fishtown

By the time of Domesday in the eleventh century, an estuary (now hidden underground) stretched far inland, and the fishing settlement of Lower Brixham was little more than a single street leading up to a small quay. For many centuries, the fishermen of the small fishing port caught fish simply to feed their families and the local population. However, by the sixteenth century, its excellent sheltered harbour and the boom in fishing caused by the Newfoundland fisheries helped Brixham to become the largest and most successful fishing port in the South West. By the late eighteenth century, the fishermen of Brixham were hugely influential, leading on the development of new fisheries and introducing new methods of fishing to fishermen all across Britain. By the late nineteenth century, Brixham's fishing fleet had reached a peak of over 300 trawlers, most owned by local family businesses, with the young men at sea and the rest of the family waiting ashore to process the catch.

By the early nineteenth century, Torbay was increasingly being used as a safe anchorage by the naval fleet during the Napoleonic Wars, who were using Brixham for regular supplies of fresh vegetables, meat and water. A consortium of local families spotted the commercial

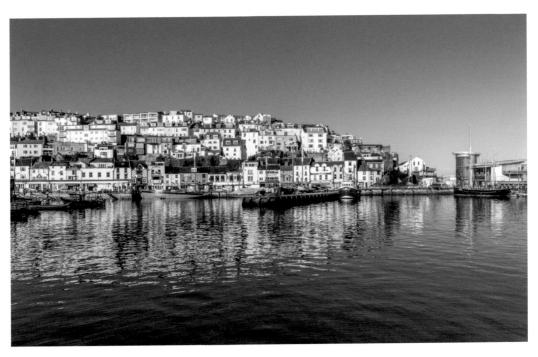

Lower Brixham (Fishtown) from across the harbour.

potential of the situation and went on to purchase and extend the harbour, significantly boosting trade through the port. Although this brought prosperity to the town's merchants, it also put significant strain on the local economy, and the resultant increase in food prices led to starvation among many of the poorest in the community. The town remained prosperous right through to the late nineteenth century, when the days of sail gradually declined and Brixham was overtaken by the larger ports at Plymouth; however, visitors to Brixham today will still find a small but active fishing port.

The Arrival of a King

On 5 November 1688, Prince William of Orange stepped ashore at Brixham, along with an army of 20,000 men. King James II of England planned to reimpose Catholicism on his mainly Protestant people, and so his Dutch son-in-law, and husband to his Protestant daughter Mary, was secretly invited by the King's Protestant opponents to invade England and take the throne. William set out from the Netherlands with his invasion fleet, but gales forced them off course and they eventually came ashore at Brixham. Thanks to the King's pursuit fleet also being hampered by the gales, William and his army were gifted three clear days to land at Brixham unopposed.

Local folklore says that William was carried ashore by a fisherman, spending the night at the fisherman's house before setting off with his army for London the following morning. Many Englishmen supported William and, after some prominent nobles defected to support the invading forces, King James II chose to flee to France and concede the throne to William. In 1689, the English Parliament offered William and Mary the joint thrones of England, Ireland and Scotland, in what was to become known as the 'Glorious Revolution'.

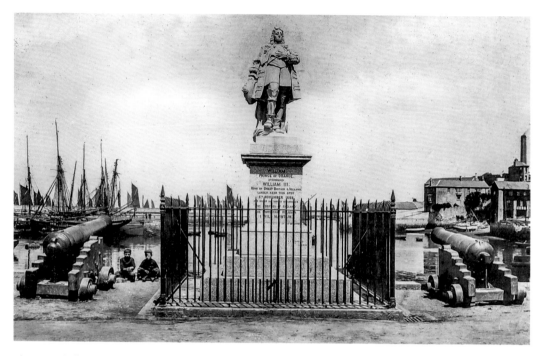

Photograph from 1899 of the statue commemorating the arrival of Prince William of Orange and his armies on 5 November 1688.

The unopposed invasion by Prince William of Orange was to become a major event in British history, both for being the last successful invasion of England and for establishing the first constitutional monarchy. Echoes of this historic event include a steep road from the harbour named Overgang (meaning 'passage' in Dutch) and a large number of people in the town with Dutch names, likely to be distant descendants of the soldiers of William's invasion force. A statue on the quay, which includes the stone upon which William allegedly first set foot in England, commemorates this historic event.

Defence of the Nation

Sheltered from frequent Atlantic gales by the promontory of Berry Head, Torbay provides excellent shelter for shipping and has been used throughout history as a refuge for ships of all nations. The sheltered bay and its facilities became especially critical during times of war, and Brixham and its headlands, including Berry Head and Battery Gardens, have played a major role in coastal defence for many centuries. With a clear view across Torbay, Battery Gardens was used as early as 1588 to host guns to protect against the Spanish Armada, although most of the features seen in the gardens today date from the Second World War. The remains of Iron Age fortifications on Berry Head show that the potential of its high promontory for defence was recognised as long ago as 800 BC. By the late eighteenth century, two defensive forts were built to defend against invasion by French troops. Many of these fortifications remain today, forming one of the best preserved Napoleonic forts in Britain.

As well as a being a peaceful refuge for shipping throughout history, the bay also regularly played host to warships, from Viking longships pillaging coastal communities, to Sir Francis

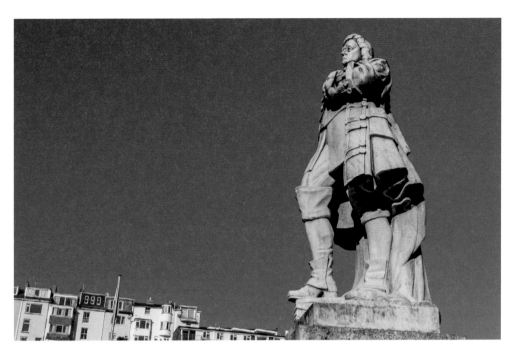

Above: Prince William of Orange overlooking the harbour at Brixham.

Right: An early image of the Coffin House, Brixham.

Drake's ships sailing to intercept the vast fleet of the Spanish Armada, to the Allied invasion fleet preparing for the D-Day landings, which would finally bring an end to the Second World War.

Red Sails and Industry

Although now mainly a tourist destination, with a replica of Drake's ship *The Golden Hind* sitting in the harbour, Brixham also has a rich industrial past. Deposits of iron ore were mined at Sharkham Point and limestone was extensively quarried around Berry Head, as were large natural deposits of ochre. The ochre was painted onto the canvas sails of trawlers to protect them from the elements, which gave nineteenth-century Brixham trawlers their characteristic red sails. Rust-resistant paint based on ochre was invented in Brixham, and its production developed into a major industry, with traces of the Torbay Paint Company factory still visible in the Freshwater car park.

Berry Head

At the southern end of Torbay, sheltering Brixham from the worst of the Atlantic storms, is the high promontory of Berry Head. With its near-vertical limestone cliffs and high natural plateau, Berry Head has been protecting Brixham and the safe anchorages of Torbay from prehistory right through to the Second World War. There is evidence of an early Iron Age promontory fortress on Berry Head, built by creating an 18-foot-high masonry rampart across the narrowest part of the headland. Although these ancient fortifications were destroyed by the construction of the Napoleonic fort, its existence is remembered in the name of Berry Head itself, a derivation the Old English *burh*, meaning 'prehistoric fort'.

The fortifications seen today are some of the best preserved Napoleonic defences in the South West, constructed from 1795 to 1809 to protect against invasion from the forces of Napoleon Bonaparte. The fort and the headland are now part of the Berry Head National Nature Reserve, an area of rare limestone grassland supporting 200 types of bird and 500 flower species. Caves on the cliffs are home to the endangered Greater Horseshoe Bat, and the seas around the headland are an excellent place to spot seals, bottlenose dolphins and basking sharks.

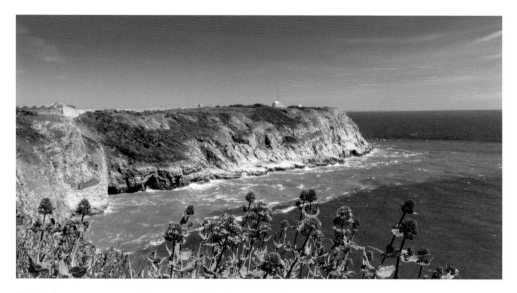

The high promontory and limestone cliffs of Berry Head.

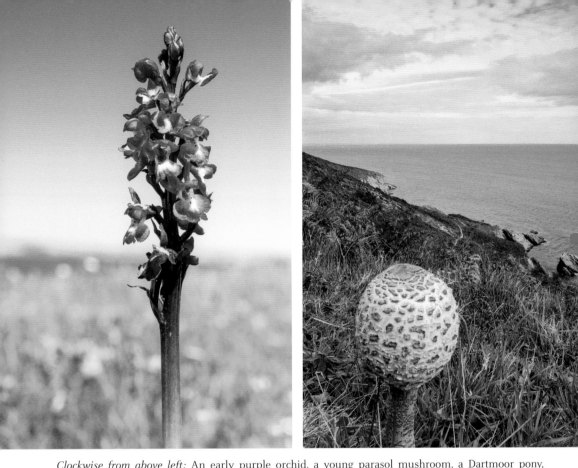

Clockwise from above left: An early purple orchid, a young parasol mushroom, a Dartmoor pony, a small tortoiseshell butterfly.

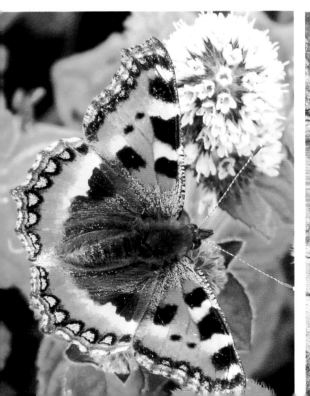

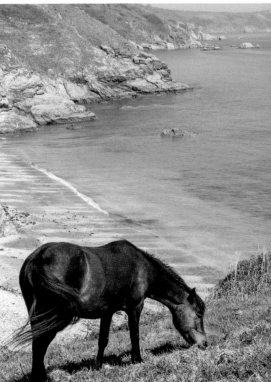

Kingswear to Strete

Kingswear

Ancient Roots

The scenic village of Kingswear clings to the hillside on the eastern side of the River Dart, a mile upstream from the river's estuary and the sea. Like its bigger brother, Dartmouth, overlooking it from the opposite side of the river, the existing settlement at Kingswear is relatively young, less than a thousand years old and not recorded until 1170. However, there are hints of far more ancient roots, with a Saxon settlement at Kingston on the plateau above the town and evidence of even more ancient Roman and Stone age activity nearby. Kingswear's name is a derivation of *King* (from the earlier Saxon settlement of Kingston) and *weare*, a reference to an early tidal water mill.

Twin Castles

Sitting on the eastern shore of the River Dart, and opposite the distinctive castle at Dartmouth, is Kingswear Castle. Constructed between 1491 and 1502, slightly later than the Dartmouth defences, Kingswear Castle was built as a coastal fort and was one of the first fortifications ever built specifically to house cannon. Due to the limited range of early cannon, Kingswear Castle was initially essential to ensure complete coverage of the estuary leading to Dartmouth's important harbour. However, its life as a defensive fort was short lived, as advances in cannon design soon meant that the castle at Dartmouth could protect the whole width of the estuary and Kingswear Castle became largely redundant. Apart from some brief military use during the Civil War and Second World War, the 500-year history of Kingswear Castle is an entirely peaceful one, with centuries of use as a private home. Today, the castle is owned by the Landmark Trust, who rent it to holidaymakers.

A History Bound to the Sea

As with nearby Dartmouth, the growth of Kingswear revolved around the sea. A ferry is known to have linked Kingswear to Dartmouth as early as 1365, and in 1636 early settlers sailed from nearby Kittery Point to North America, where they founded the town of Kittery, Maine, named in honour of their point of embarkation. From the twelfth century, Kingswear was the preferred landing place for European pilgrims en route to the shrine of Thomas à Becket at Canterbury. Becket was Archbishop of Canterbury and was made a Catholic saint and martyr after he was brutally murdered by followers of his enemy, King Henry II.

Despite having a similar early history to Dartmouth and a number of major advantages, such as more direct land routes to Exeter and a direct rail link, Kingswear never developed to the same extent as Dartmouth. This is almost certainly due to simple logistics, with its steeper hillsides and lack of flat land for building making growth much more difficult. Kingswear therefore remains a small scenic village, with colourful houses lining narrow

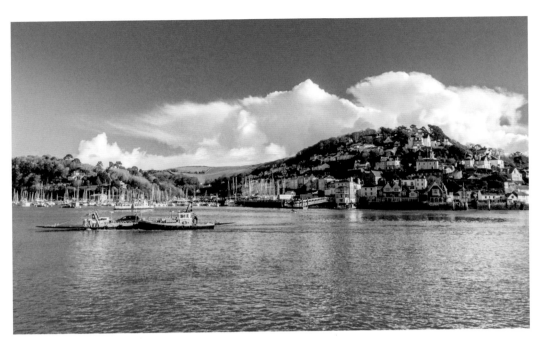

The lower ferry with Kingswear in the background.

streets as they climb steeply from the heritage railway station and the ferry slipway, where passengers once departed for destinations around the world. Despite being smaller than neighbouring Dartmouth, locals will point out that Kingswear will always have the major advantage of being on the sunnier side of the river!

Dartmouth

Prehistoric Origins

Archaeological evidence suggests that the picturesque estuary of the River Dart, with its natural deep water harbour, has been a base for human activity stretching well back into prehistory. Worked flints found in South Town suggest the presence of a Mesolithic settlement between 10,000 and 4,000 BC, and flint tools and a beautiful carving of a human face found near Capton provide evidence of continued habitation into the Neolithic period (4,000–2,500 BC). During the Iron Age, Dartmouth's sheltered harbour would have been attractive to Celtic people, who settled here between 800 and 500 BC, leaving evidence of their lives through the Iron Age forts near Dartmouth and nearby Noss Mayo. Although no evidence of a Saxon settlement has ever been found, there are many Saxon place names nearby, suggesting that Saxons were regular visitors to the area when they began settling in Devon from the seventh century AD.

As with all early coastal settlements, the origins of modern Dartmouth lie inland, well away from coastal dangers such as Viking raiding parties. The first origins of the town lie a mile inland from the estuary, with the small settlement of Townstal on the hillside as it rises from the western banks of the Dart. Originally called *Dunestall*, meaning 'homestead on the hill', the hamlet was first mentioned in the Domesday Book.

By the Norman Conquest in the eleventh century, two new riverside settlements called Clifton and Hardness began to develop on the banks of the river below Townstal, separated

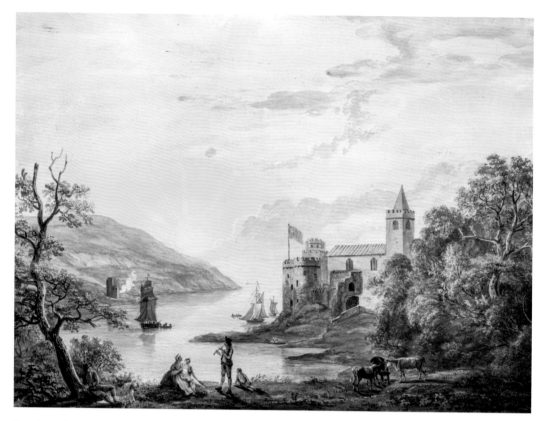

Painting of Dartmouth Castle and St Petrox church around 1794, by Paul Sandby.

by a deep tidal inlet, which ran far inland. The area of mudflats around this inlet provided the only flat land in Dartmouth and was reclaimed for development in a number of stages from the thirteenth century onwards, including the development of the current embankment by Napoleonic prisoners of war during the nineteenth century. The settlements of Clifton and Hardness soon became known as Clifton-Dartmouth-Hardness and, along with Townstal, the three medieval settlements were the origins of modern-day Dartmouth.

Castles and Cannon

The picturesque Dartmouth Castle has been standing guard on its prominent rocky headland above the Dart estuary since the fourteenth century. During the time of the Hundred Years War, the increasing strategic importance of the port made it an obvious target for French attack. In 1388, John Hawley, a wealthy local merchant and Mayor of Dartmouth, successfully appealed to King Richard II for the authority to build a fortification to defend the estuary. The original structure, built at the narrowest point of the estuary, was a simple enclosure castle with a ring of towers surrounded by a curtain wall (some of which remains above the modern car park) and housed simple weapons such as stone-throwing catapults. Although a simple structure, the defences appear to have been successful in deterring invaders, and when a 6,000-strong French army did attack, they chose the less well defended areas around Slapton further down the coast.

Brownstone Battery is one of only a few remaining Second World War coastal defence batteries built during the peak of fears of Nazi invasion. The battery was heavily armed and had a commanding view across Start Bay, including the beaches of Slapton, where the Allied troops prepared for the D-Day landings in 1944.

Standing majestically overlooking the River Dart is the striking Daymark Tower, built in 1864 to help guide mariners safely into the estuary.

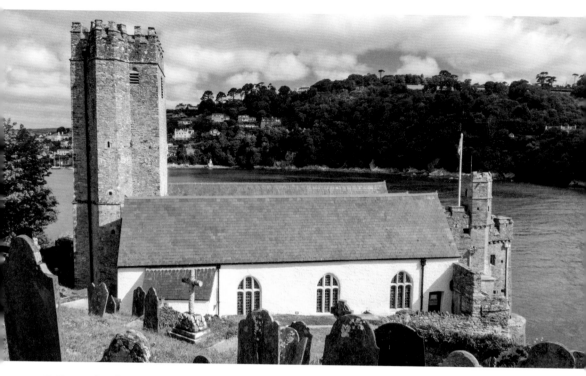

St Petrox church, first recorded in 1192.

By 1462, a chain fortification was installed across the mouth of the river. Although the stated purpose was to prevent enemy ships from entering the estuary during times of war, local rumour suggested that it was more frequently used to stop merchant ships leaving before locals could extract as much tax from them as possible! An imposing gun tower was added to the castle in 1481, and in 1491 it was one of the first fortifications in Britain to install huge cannon called 'murderers', capable of sinking ships. With the completion of a sister castle on the opposite side of the river in 1502, Dartmouth became one of the best defended harbours in the country.

Further improvements to Dartmouth Castle were made in the sixteenth century as part of Henry VIII's modernisation of England's coastal defences. However, despite all the preparations for invasion, the main action seen by the castle was not to come from foreign invaders, but instead from the home-grown conflict of the English Civil War. Royalist forces took control of the castle in 1643, building the earthwork fort of Gallants Bower above the castle to defend it from land-based attack; however, the Parliamentarian forces of Sir Thomas Fairfax eventually reclaimed it in 1646. The castle continued to be used as a working fortification right through to the twentieth century, with its final military use as a gun position during the Second World War.

One of the most striking buildings within the castle grounds is St Petrox church, named after the Welsh St Petroc, who is said to have converted the Cornish King Constantine to Christianity. The church predates the castle, with the first mention of a religious building on the site being a reference to the 'monastery of St Peter' in 1192. It is likely that the monks of the early monastery would supplement their income by maintaining a navigation light

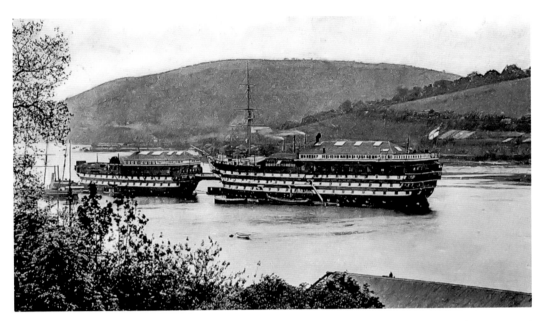

The original nineteenth-century Naval College, on board HMS *Britannia* and HMS *Hindostan* moored on the river at Dartmouth.

to guide ships into the estuary. Much of the current church structure was remodelled in the seventeenth century, and the church and its churchyard hold the remains of many of Dartmouth's eminent merchant families.

Trade, War and Prosperity

There is evidence of trade from Dartmouth's natural deep-water harbour stretching far back into prehistory; however, it was the Normans in the twelfth century who recognised its potential and developed it into a significant trading port. The majority of early trade was with the west coast of France and Spain, with the export of wool and grain and the import of wine. However, the acquisition of the south-western provinces of France by Henry II in 1152 gave a major boost to trade through the port, leading to a period of prosperity throughout the Middle Ages and making it the fourth richest town in Devon by the fourteenth century. A further period of prosperity came during the sixteenth century, when the town's fishermen played a central role in the development of the Newfoundland fisheries and the port also developed a flourishing trade in the export of cloth from the textile mills inland at Ashburton. Port trade declined steeply during the eighteenth century following the collapse of Devon's textile industry and, although there were attempts to grow Dartmouth as an embarkation point for Atlantic shipping during the late nineteenth century, these were largely unsuccessful due to the lack of a direct rail link to the town.

As well as trade, Dartmouth has also played an important military role, as well as being at the centre of some key moments of British history. The port was the assembly point for the ships of the Second and Third Crusades in 1147 and 1190, as they set off to reassert Christianity in the Holy Land, and in 1588 the town sent a fleet of ships to help defend the nation against the Spanish Armada. One of the ships captured by Sir Francis Drake was moored in the harbour for over a year, with its captured sailors put to work within the town.

Dating from the fourteenth century, St Saviour's church contains the tomb of Dartmouth's eminent mayor, John Hawley.

Dartmouth was also visited by the Pilgrim Fathers on board the *Mayflower* in 1620 before leaving for America to establish a new colony in Plymouth, Massachusetts.

The town was badly bombed during the Second World War due to the presence of shipyards along the Dart and the Britannia Royal Navy Officer Training College. Training naval officers since 1863, the Naval College was initially based on ships moored on the river, but eventually moved to an imposing building on a hillside overlooking the Dart in 1905. The Dart estuary was also important in the closing stages of the Second World War, when it was used to house hundreds of Allied boats preparing for the D-Day landings.

Medieval Remains

Dartmouth today retains many features from its medieval past, including narrow, winding lanes, steep stone stairways and many historic buildings. Among the oldest buildings is the Cherub public house in Higher Street, originally a merchant's house built around 1380. The earliest recorded street in Dartmouth is Smith Street, named after the smiths and shipwrights who plied their trades here during the thirteenth century. Now well inland due to later land reclamation, Smith Street was originally located on the riverbank, and as late as 1567 ships were still being moored to the walls of St Saviour's church. Dating from the mid-fourteenth century, the church contains the tomb of the town's eminent mayor, John Hawley, and its gallery is believed to have been constructed from the timbers of captured Spanish Armada ships. Further land reclamation during the seventeenth century led to the development of Duke Street, the historic Royal Castle Hotel (built in 1639) and the Butterwalk (built around 1635), where King Charles II held court in 1671 while sheltering from a storm at sea.

Dartmouth People

One of Dartmouth's most famous sons is John Hawley, who was born near Dartmouth in 1340 and went on to be a major influence in the town during much of the fourteenth century. Hawley was a talented man who was elected mayor fourteen times, served in Parliament twice, and even organised the defence of the town against French armies at the Battle of Blackpool Sands. Hawley was also a successful merchant and a licensed privateer, raiding enemy ships under licence to the King. The eminent English poet Geoffrey Chaucer was known to have visited Dartmouth and met Hawley, and his tale of 'The Shipmen' in *Canterbury Tales* tells of a colourful character from Dartmouth with a penchant for piracy. Although unlikely to be directly based on Hawley, the character is likely to incorporate the characteristics of the many, often lawless, Dartmouth seamen of the time.

Another notable Dartmouth resident was the inventor Thomas Newcomen. Born in Dartmouth and an ironmonger by trade, Newcomen improved on earlier designs to produce the first practical coal-fired engine for pumping water out of flooded mines. Although not very efficient, the engines were rugged and reliable and were extensively used in Britain and Europe throughout the eighteenth century. A blue plaque marks the original position of his house, although unfortunately it was demolished in the nineteenth century to build the road that now bears his name.

Strete

As well as having wonderful views over Start Bay, the small village of Strete has a long and interesting history. Its name is a derivation of the pre-sixth-century word *straet*, meaning a paved road, hinting that the history of the village may be intricately linked to the road that runs through it, now the busy A379. Most town names derived from *straet* tend to be connected to Roman roads or centres of trade. However, until recently there was little evidence of Roman activity west of the Exe. Recent finds nearby, including a coin hoard and a possible Roman road, suggest that Roman activity in the area may have been underestimated, and Strete could well have developed along an ancient Roman road, possibly one that linked Exeter to South Devon's ports.

Although a quiet, unassuming village today, Strete also has a history linked to war. The village was evacuated and occupied by US forces during preparations for the D-Day landings, and also witnessed one of the last invasions of England by a foreign power. In 1404, during the Hundred Years War, a French force of 300 ships and 2,000 men came ashore at Blackpool Sands in an attempt to make a land-based attack on Dartmouth. They were met by a local force assembled by John Hawley of Dartmouth, who went on to defeat the French forces at the Battle of Blackpool Sands.

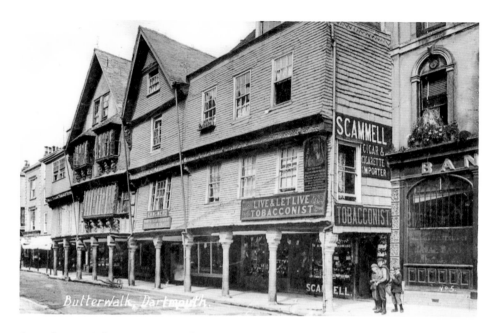

An early twentieth-century image of the Butterwalk, where King Charles II held court in 1671.

Seal eating a fishy lunch in Dartmouth Harbour.

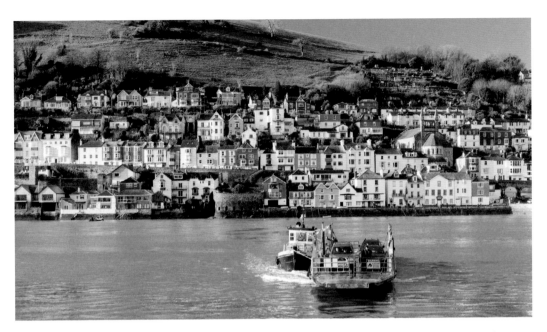

The lower car ferry heading for Kingswear. There are records of a ferry across the River Dart between Kingswear and Dartmouth as early as the fourteenth century. Several attempts to build a bridge across the Dart failed to materialise, but today three ferries regularly carry people and vehicles between the towns.

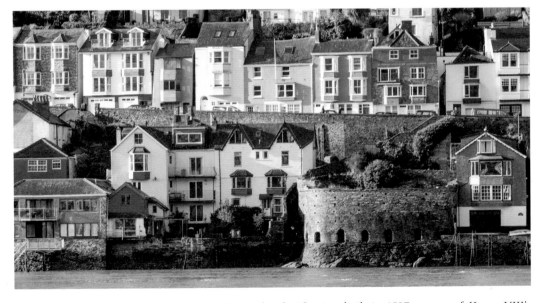

Bayard's Cove Fort is the remains of a Tudor fortification built in 1537 as part of Henry VIII's enhancement of coastal defences. The fort marks the location of the original port of Dartmouth and was designed to protect the town, should enemy ships break through the main defences at the mouth of the estuary.

Slapton to East Portlemouth

Slapton

A Slippery Place

5 miles south of Dartmouth, and half a mile inland from the shingle bank of Slapton Sands, is the ancient village of Slapton. First documented in the Domesday Book as 'Sladown', its name is a derivation of the Old English word *sleape*, meaning 'the slippery place', presumably a reference to its soggy position surrounded by five streams and the waters of Slapton Ley. Sitting on a promontory above a freshwater lake with plentiful flora and fauna made Slapton an attractive place for early settlers, and the Iron Age hill fort of Slapton Castle nearby is evidence of people living there as early as 800 BC.

At the time of Domesday, the medieval village of Slapton had twenty-six male villagers of working age and twenty-one cottagers (low-class peasantry), looking after nine cattle, twelve pigs and 100 sheep. Women and children were not recorded, but it is thought that Slapton was home to around 200 people, making it larger than nearby Dartmouth, which, in 1086, was too insignificant to be recorded by the Domesday scribes.

Now tucked away in the centre of the village, the Tower Inn was originally built to house the men working at the nearby chantry of St Mary. The chantry was founded in 1373 by Sir Guy de Brian, standard bearer to King Edward II, and was set up to house priests whose sole purpose was to pray for the souls of the dead and ensure their entry into heaven.

Slapton Sands and the Ley

The 2-mile-long shingle ridge of Slapton Sands was formed 3,000 years ago during a period of rising sea levels. As waters rose, a pebble ridge formed around the edge of Start Bay, eventually linking the headland at Strete Gate with the one at Torcross. The ridge dammed a stream called The Gara, leading to the formation of the freshwater lagoon of Slapton Ley, which is still separated from the sea by the shingle bank. The Ley is now a National Nature Reserve and one of Britain's most important wetland reserves, providing a home to a huge variety of wildlife, including otters, bats, songbirds and butterflies.

War Comes to the Bay

For centuries, Slapton remained a sleepy village, but all of that changed during the latter stages of the Second World War, when nearby beaches became the centre of preparations for the D-Day landings. Start Bay had been chosen because of its proximity to the planned embarkation ports around Torbay and the similarity of its beaches to those of the Normandy Coast. In 1943, the government gave 3,000 people around Start Bay, including the residents of Slapton, just six weeks to evacuate their homes and leave the area clear for the arrival of troops.

On the night of 28 April 1944, part of the full-scale rehearsal for D-Day called Operation Tiger took place in the bay. Eight landing craft and an escort ship were passing Slapton

Above: Slapton Sands from Torcross.

Right: A Sherman tank at Torcross
as a tribute to the many who died in
Operation Tiger.

Sands when a group of German E-boats on a routine reconnaissance stumbled across the convoy and opened fire. Two landing crafts were sunk and nearly a quarter of the 4,000 troops were killed. The exercise continued, but with several hundred more troops dying due to friendly fire, the exercise soon became a tragedy. The planners of the D-Day landings were so concerned about the effect on troop morale so close to the critical Normandy invasion that the events of April 1944 were covered up and remained secret for the next forty years.

Lost to the Sea

As well as the power to create the shingle bank of Slapton Sands, the seas have demonstrated their tremendous destructive power around the coast of Start Bay. For centuries, the small fishing village of Hallsands lay just to the south of Torcross, perched between the cliffs and the sea, and by 1891, was a thriving village with a public house and a population of 159. However, in the late nineteenth century, nearby dredging for shingle to build Devonport Dockyard caused the beaches to erode, leaving the village unprotected from the full power of the sea. During a particularly severe storm in 1917, most of the village was destroyed, and those buildings that remained were quickly evacuated. Today, there are few remaining signs that the village of Hallsands ever existed, apart from the ruins of a couple of houses still clinging to the cliffs. Hallsands was not the only village in the area to be lost to the sea, with records showing that another village called Undercliffe Lakes on the cliffs below Strete disappeared below the waves around the 1780s.

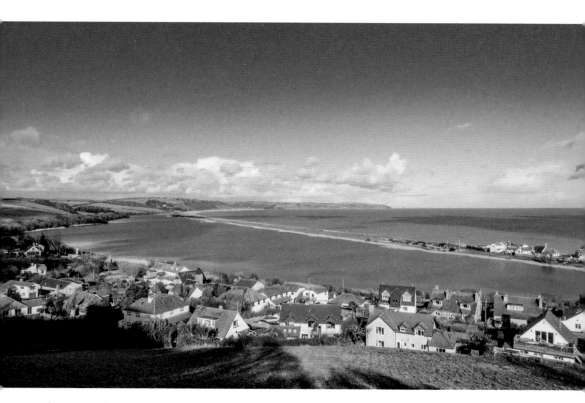

Slapton Ley from above Torcross. The shingle bank in the far distance separates the freshwater lake from the sea.

Torcross

At the southern end of Slapton Sands is the picturesque village of Torcross, which was first recorded in 1602 as part of the manor of Stokenham. The small fishing village developed at a time when an effective Navy finally made it safe to live on the coast, after centuries of danger from invading forces and pirates. One theory for how Torcross got its name is that it is derived from 'Tar Crofs', the name of the dwellings where fishermen used to dip their ropes and nets in tar in order to make them waterproof. While crab was the main catch at nearby Beesands and Hallsands, Torcross fishermen were largely involved in open-water fishing for mackerel, pilchard and herring.

Along with other villages in the South Hams, in 1943 the residents of Torcross were evacuated to make way for 30,000 Allied troops to prepare for the D-Day landings that would eventually lead to the end of the Second World War. Thanks to the generosity of a local man, one of the Sherman tanks that was lost offshore during the ill-fated Operation Tiger was recovered from the sea in 1984, and now stands in the car park at Torcross as a tribute to the many young men who lost their lives.

The village's exposed position on Start Bay has led to a long battle with the elements. Huge storms devastated the seafront in 1951, and in 1979 the waves were so large that they washed right over the roofs of houses on the seafront, leading to the construction of an extensive sea wall to provide some protection from future storms.

Beesands

Overlooking Start Bay, and a mile south of Torcross, is the small village of Beesands, where people first settled in the sixteenth century. The first written record of the village is from

Boats on Beesands beach.

1588, when a resident of nearby Beason reportedly broke into a fisherman's house and stolen his nets, a crime for which he was put into the stocks and whipped.

By the nineteenth century, Beesands had a population of 100 people, many involved in fishing in the bay and making their living from a flourishing trade in crab, lobster and eel. By the end of the century, the village had thirty houses, a public house and dozens of boats working from the beach, sending up to eight tons of crabs to Billingsgate market every week during the summer months. Fishing declined during the twentieth century when small beach-launched boats were overtaken by large trawlers. However, the local pub, the Cricket Inn, still serves locally caught crab, as well as being the location of Mick Jagger's first public performance in the 1950s.

Start Point

To the south of Beesands at the southernmost tip of Start Bay is the impressive and beautiful promontory of Start Point, its name a derivation of the Anglo-Saxon 'steort' meaning 'tail'. At almost the most southerly point in Devon, Start Point is one of the most exposed peninsulas on the south coast of England, jutting out almost a mile into the English Channel. The attractive Start Point lighthouse was built in 1836 to warn ships off the treacherous Skerries Bank, and its light can be seen by shipping more than 25 nautical miles out to sea. Local legend has it that the notorious local pirate Henry Muge was hanged at Start Point in 1581, and his ghost is said to still haunt the lighthouse.

The Salcombe ferry heading for East Portlemouth. The village of East Portlemouth sits on a hillside above the scenic Salcombe and Kingsbridge estuary, with stunning views over Salcombe and the surrounding countryside. The village was once a flourishing port and a home to shipbuilding, providing one of the ships that pursued the Spanish Armada in 1588.

The Start Point Lighthouse, guiding ships off the
dangerous rocks since 1836. *Overleaf:* The dramatic
headland of Start Point.

A History of Cider

Cider (often called Scrumpy) is a traditional Devon tipple, with a history stretching back
at least a thousand years to the time of the Norman Conquest. Although traditional
sour apples had grown in Britain since Neolithic times, sweet varieties and managed
orchards first arrived with the Romans in the first century AD. Cider making appears
to have developed much later in history, and was likely to have been introduced by
the Normans, who already had a strong tradition of apple growing and cider making
when they arrived in Britain in the tenth century. It was not until the thirteenth century
that cider making was officially recorded in Britain, by which time many monasteries
appear to have had their own cider presses, often selling cider to the public.

By the Elizabethan period, cider was regularly supplied to ships visiting South
Devon's coastal ports, and by 1754 the *Compleat Cyderman* described Devon as a
leader in the management of fruit orchards. By the eighteenth century, annual cider
production had reached 45 million litres (around 150 litres for every Devon inhabitant)
and vast quantities were being shipped from South Devon's ports to London, where
it was often adulterated and sold on as imported wine. Throughout the Victorian era,
apples were extensively grown by farmers to supplement their income, and orchard
workers were often part paid by substantial daily allowances of cider, a practice that
was eventually banned in 1917.

Throughout history, cider was believed to have health-giving properties and promote
a longer life. The importance given to cider apples can be seen in the traditional wassail
ceremony, where cider is poured around the roots of the trees, and cake soaked in cider
is placed in the branches to honour the spirit of the tree and promote a healthy crop.

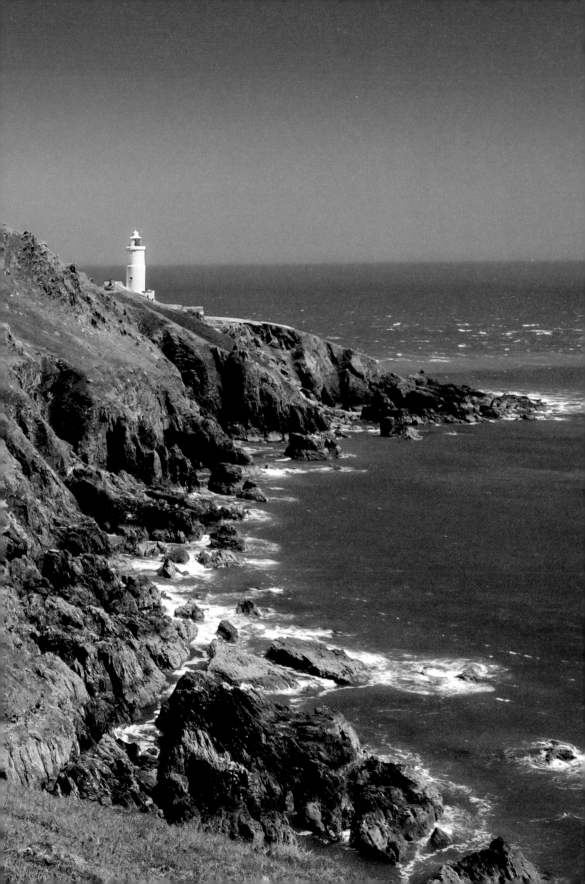

Salcombe to Burgh Island

Salcombe

The picturesque town of Salcombe was originally called *Saltcombehaven*, a reference to the salt panning that was once carried out here. Clinging to the steep, western bank of the Salcombe and Kingsbridge estuary, Salcombe is less than a thousand years old and, unlike many nearby settlements, it did not exist at the time that the Domesday Book was compiled in 1086. However, people have been living and working around its beautiful, sheltered estuary since early history, with evidence of Stone Age settlements found on the hilltops above the town and on the opposite side of the estuary.

The early history of Salcombe is somewhat sparse, which is not unusual since literacy levels were low in the Middle Ages and written records are therefore few and far between. Salcombe was first recorded in 1244, although at that time it was likely to be no more than a cluster of buildings where fishermen kept their nets. By 1342, some activity was recorded as taking place in the harbour, where a number of boats were hired to transport troops to Brittany during the Hundred Years War, and in 1403 there were raids by French forces. During the 1530s, John Leland, a Tudor poet and antiquary, described Salcombe as 'somewhat barrid' (presumably meaning barren) and a 'fisshar toune'. As it was when Leland visited, much of Salcombe's early history is likely to have revolved around the sea, and by the 1570s, five ships and fifty-six mariners were said to be working from the naturally sheltered harbour.

A Ships' Graveyard

The coastline around Salcombe is beautiful but also treacherous, and has been responsible for the demise of many ships. As a result, the seas around Salcombe are scattered with shipwrecks, including that of a 3,500-year-old Bronze Age trading ship that was discovered at the mouth of the estuary in 2009. The ship's cargo included gold bracelets and copper and tin ingots from mainland Europe, providing the earliest evidence ever found in Britain of an ancient cross-Channel trade in metals. In 1995, the remains of a seventeenth-century ship was found to contain a cargo of Moroccan gold coins, Dutch pottery and even an apothecary's pot, complete with pills. Although the wreck was most likely to have been that of a trading ship, some of the coins dated from a time of intense activity by Barbary pirates, providing speculation that the wreck could have been a pirate ship. The wreck of the *Ramillies*, found further down the coast near to Hope Cove, has a much better documented story. The *Ramillies* was a ninety-gun man-of-war, which left Plymouth in 1760, sailing directly into a vicious storm. After nine days of being blown around the English Channel, the ship desperately tried to head for home, but was smashed to pieces on the rocks, with all but twenty-six of the 730-man crew meeting their deaths.

The ferry arriving at East Portlemouth, overlooking Salcombe.

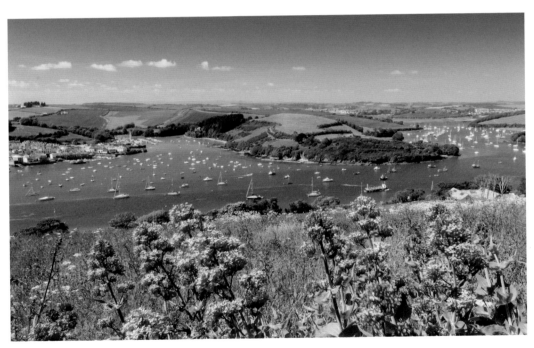

The Salcombe and Kingsbridge estuary, which runs more than 6 km inland, is a 'ria', an estuary formed when a natural valley is inundated by rising sea levels. As well as being extremely scenic, the tidal estuary provides many rare habitats, which are home to an abundance of wildlife.

Bluebell fields overlooking the entrance to the Salcombe and Kingsbridge estuary.

A 300-year-old Admiralty flag signal station on the cliff top at Soar near Salcombe, built as a lookout for French invasion fleets.

The Royalists' Last Stand

To the south of the town are the ruins of Salcombe Castle (also known as Fort Charles), originally built by Henry VIII in 1544 to defend the estuary from attack by Spanish and French pirates. The castle played a major role in the English Civil War during the mid-seventeenth century, when it was strengthened and used as a Royalist garrison by Sir Edmund Fortescue. The castle withstood two sieges, the second lasting more than four months, and the castle became the last place in Devon to hold out against Parliamentarian troops, until the Royalists finally surrendered in 1644. The castle was seen to be too dangerous to remain as a fortification and Parliament ordered it to be destroyed. However, the remains of one tower can still be seen on a rocky outcrop near to South Sands Beach.

Ships and Pineapples

During the nineteenth century, Salcombe developed into a significant centre for shipbuilding, and over 300 sailing vessels were built in and around the estuary. By 1871, the town had 776 inhabitants, and many of them were involved in trades associated with shipbuilding, including shipwrights, carpenters, sailmakers and blacksmiths. Initially, many of Salcombe's ships were involved in trade with Newfoundland, with salt being exported before returning with cargoes of preserved fish. However, a thriving trade in fruit imports later developed from the town, with fast Salcombe schooners importing perishable cargoes of citrus fruit from the Azores and pineapples from the West Indies.

Much of the foreshore of Salcombe was reclaimed during the eighteenth and nineteenth centuries in order to provide additional space for the shipyards, and many of the town's distinctive buildings were constructed during this time, including many large houses for the increasingly wealthy shipowners. By the late nineteenth century, the arrival of larger steam ships meant the decline of Salcombe's shipbuilding industry and much of its trade; however, the town went on to become a centre for leisure sailing, which it remains to the present day.

A Time of War

As with many Devon towns, the Second World War left its mark on Salcombe, with the town suffering a number of German tip-and-run bombing raids. However, it was still safer than London, and over a thousand children from the East End were evacuated to the town. The town's main role in the war came near its end, when it became one of the main centres of preparation for the Normandy landings. From the end of 1943, Salcombe became an advance amphibious base for the US Navy, and much of the town was requisitioned for naval use. The Salcombe Hotel became the Navy's headquarters, and many of the town's large houses became temporary home to almost 2,000 US troops. A slipway was built at Whitestrand Quay and, on 4 June 1944, sixty-six ships and support vessels sailed for Utah Beach to begin the attack on German-occupied France.

The remains of Salcombe Castle, built on the orders of Henry VIII to defend the Salcombe estuary from attack.

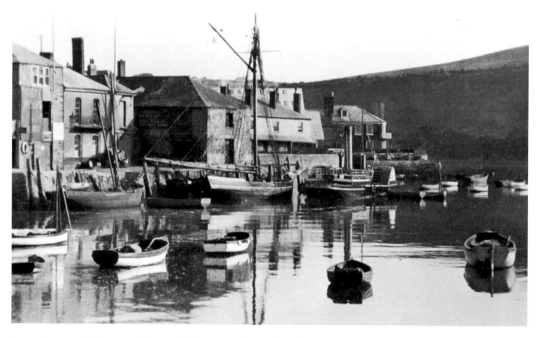

An early twentieth-century image of the quayside at Salcombe.

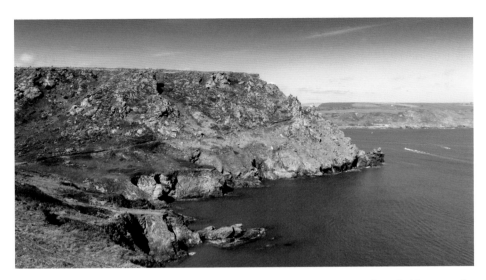

To the west of the entrance to the Salcombe and Kingsbridge estuary, and nestled between the promontories of Sharp Tor and Bolt Head, is the beautiful Starehole Bay. It is one of the author's favourite South Devon spots for its natural beauty and tranquillity.

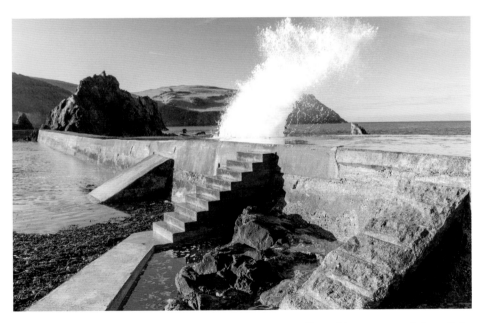

Waves breaking over the breakwater at Hope Cove, a small seaside resort consisting of the villages of Outer Hope and Inner Hope, which were first recorded in 1281. For much of its early history, the inhabitants made their living from the sea, fishing for pilchard and plundering shipwrecks. Hope Cove is famous for being the only place in England where Spanish sailors made land, after one of the Armada ships was wrecked on Shippen Rock in 1588 and the survivors were brought ashore before being ransomed and sent back to Spain.

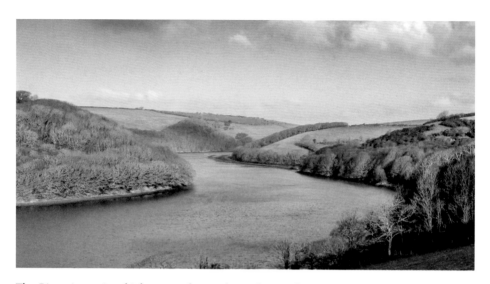

The River Avon rises high up on the southern slopes of Dartmoor, passing through Aveton Gifford before meeting the sea at Bigbury-on-Sea, a village that sits overlooking Burgh Island and the largest sandy beach in Devon. At the mouth of the Avon, fresh water mixes with seawater and provides perfect conditions for growing oysters. Hundreds of thousands are grown and harvested here every year.

Rising on Dartmoor, the River Erme flows through Ivybridge before meeting the sea at Bigbury Bay, and is one of the most unspoilt and beautiful estuaries on the South Devon Coast. Many ships have been lost around the jagged rocks around the estuary, including a 4,200-year-old Bronze Age ship carrying a cargo of tin ingots, possibly en route to Burgh Island, which was thought to be a prehistoric centre of tin trading.

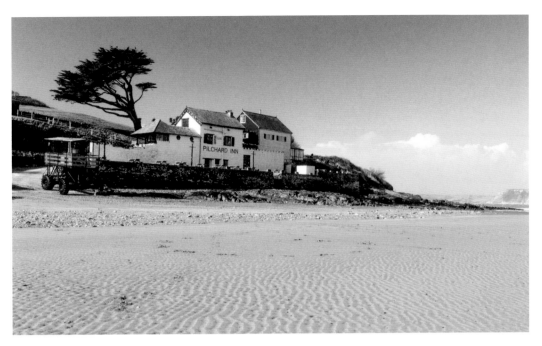

The Pilchard Inn, Burgh Island.

Burgh Island

Burgh (pronounced 'Burr') Island sits just off the coast where the River Avon meets the sea. The small, rocky island can be accessed on foot at low tide via a sand causeway, or at high tide via the ingenious sea tractor that has been ferrying visitors to the island since the 1960s. For an island of only 27 acres, Burgh Island (previously known as St Michael's Island) has had a long and colourful history. There is evidence that the island was at the centre of prehistoric trade, and some of the island's earliest inhabitants were the monks of an early monastery, the remains of which lie under the Burgh Island Hotel. There was also an early fifteenth-century chapel (dedicated to St Michael) on the island, and the fourteenth-century Pilchard Inn, originally built as lodgings for the monastery, still operates as an inn to the present day.

The monks left the island in the sixteenth century following the dissolution of the monasteries, and the island was then mainly used by huers, who were lookouts tasked with spotting shoals of pilchards and alerting local fisherman with a 'hue and cry'. The remains of the huer's hut lie at the highest point on the island. The island was also home to smugglers bringing in illicit goods, including Tom Crocker, one of the area's most infamous Elizabethan smugglers. A tunnel connected the Pilchard Inn to caves on the shore, which were only accessible by sea and provided Tom with an ideal route to bring contraband ashore out of sight of the Excise men. However, the law eventually caught up with him and he was shot dead at the entrance to the Pilchard Inn, which local legend suggests is still haunted by his ghost.

In more recent times, the island is renowned for its striking Art Deco hotel. Built in 1927, the hotel was visited by a number of iconic twentieth-century figures, including Churchill and Eisenhower, who met at the hotel to plan the D-Day landings. Edward and Mrs Simpson and Agatha Christie have also been welcomed as guests.

View from the remains of the huer's hut on Burgh Island.

The Golden Age of Piracy

One of the many things that the West Country is famous for is as the traditional home of pirates. Just as the remote coves and inlets of the South Devon coast were perfect for helping smugglers evade customs men, they were also perfect for helping pirates ply their trade. The typical on-screen pirate even tends to talk in a West Country accent, which may be partly due to some of the most infamous pirates in history being from these parts, but is more likely to be due to early on-screen pirates choosing to adopt a classic West Country accent. One of the most likely suspects is Robert Newton, who chose to use a West Country accent when playing Long John Silver in the 1950 Walt Disney production of *Treasure Island*.

As long as the oceans have been used for trade, there have been pirates on the high seas looking for likely victims. Piracy is known to have taken place more than 2,000 years ago in ancient Greece, when pirates targeted the ships sailing their ancient trade routes. The best-known pirates of medieval Europe were the Vikings, whose name literally translates to 'sea raider'. Sailing in their wooden longships from Scandinavia from the eighth to eleventh centuries, the Vikings were renowned for attacking monasteries and coastal settlements all over Europe, including those of the South Devon coast.

By the seventeenth century, the main pirate threat to the shores of South Devon came from Barbary Corsairs from North Africa. These pirates from the Barbary Coast of present-day Morocco, Algeria and Tunisia were known to have captured 466 British ships between 1609 and 1616, selling the sailors into a life of slavery. Coastal communities along the South Devon coast were also at risk, and lived in constant

terror from the Corsairs' raids. An estimated 9,000 British people were kidnapped between 1677 and 1680, and many would have met horrible deaths as slaves on the Barbary Coast.

The golden age for West Country pirates came between 1620 and 1720, as South West ports became a focus for the growing trade with Europe and naval operations in the many wars with France. Life as a merchant or Navy seaman was harsh and poorly paid, and conditions on board ship were often terrible. Unsurprisingly, many were attracted to an alternative life of piracy, where crews were better treated and ordinary seamen could quickly become rich from the spoils that were often shared among the pirate crew.

Although some pirates were bloodthirsty, piracy during its golden age was generally a rather bloodless affair, with pirates often using flags to frighten ships to surrender without the need for a fight. The first flags were blood red, indicating that no mercy would be shown if pirates had to board and fight for the ship. Some pirates developed their own flags, the most famous of which was the Jolly Roger (a skull and crossbones), which is still synonymous with pirates to the present day. Once captured, pirates would take the ship's cargo, which often included silk, spices, brandy, wine and slaves, and the ship's crew would be taken as slaves or given the opportunity to join the pirate crew.

Some pirates were so prolific that their names are still recognised today. While Bristol had the infamous Edward Teach, better known as Blackbeard, Devon had Henry 'Long Ben' Every. Born in Newton Ferrers around 1653, Every served on merchant and naval ships before turning to piracy, and went on to become one of the most feared pirates on the Red Sea. His biggest haul came from the capture of the *Gang-i-Sawai*, a ship belonging to the Grand Moghul of India's fleet, from which Every's crew plundered the huge sum of £600,000 of gold, silver and jewels. Each pirate received £1,000, or the equivalent of 80 years' wages for a legitimate sailor.

Sir Francis Drake and Sir Walter Raleigh are renowned for being eminent Elizabethan seamen and explorers. However, what is less well known is their role as privateers, essentially legalised pirates, who were licensed by the Crown to attack and pillage the ships of enemy nations. In the sixteenth century, Sir Francis Drake attacked Spanish treasure ships returning from the New World, before sharing his substantial plunder with Queen Elizabeth I and being knighted for his services. There was a fine line between privateering and piracy, and the possession of a licence was the only thing preventing privateers from being charged and put to death by public hanging, the standard punishment for piracy.

Henry Every's skull and crossbones pirate flag, used to scare ships into surrendering without a fight.

Noss Mayo to Plymouth

Noss Mayo and Newton Ferrers

A few miles east of Plymouth lie the secluded villages of Newton Ferrers and Noss Mayo, which sit opposite one another on a creek of the unspoilt Yealm estuary. Despite the inevitable changes of the modern era, the picturesque villages of Newton and Noss remain some of the most unspoilt in Devon.

The manor of Newton was established in the ninth century AD, when the Saxon King Æthelwulf created a royal estate stretching from the River Dart in the east to the Plym in the west. By Domesday in 1068, Newton was owned by the Valletort family of Trematon, who passed it on to the Ferrers family in the twelfth century. The Ferrers arrived from France with William the Conqueror, and added their family name to the village, making it Newton Ferrers. The village of Noss Mayo lies in the ancient manor of Revelstoke, and was first recorded in 1286 as *Nesse Matheu*, meaning 'Matthew's Nose', when the manor was granted to Matthew Fitzjohn by King Edward II.

Both villages started life as a scatter of riverside huts, and were initially used by fishermen to store their boats and equipment before being converted into permanent dwellings around the fourteenth century. Fishing became a major industry for both villages, with a survey of vessels in 1326 recording a 40-ton ship sailing out of Newton Ferrers, and thirteen fishing boats being sent to assist the Royalists during the siege of Plymouth in 1643.

The remains of the church of St Peter the Poor Fisherman sit on the clifftop near Stoke Point. An early church built in the thirteenth century, it was some distance from the villages it served, and is likely to have doubled up as a landmark for shipping on this rugged and dangerous stretch of coast.

Notable characters from in and around the villages include Henry Every, the notorious seventeenth-century pirate who was born in Newton Ferrers, and two of the wives of Henry VIII, Katherine Howard and Katherine Parr, who both spent time living within the manor of Revelstoke.

Wembury and the Great Mewstone

On the banks of the Yealm estuary sits the small village of Wembury, with extensive views from Wembury Point back over the Yealm estuary, and onwards past Plymouth to Rame Head in Cornwall. Wembury is likely to have been a farming settlement since the Saxons arrived in the seventh century AD. However, there is evidence of more ancient visitors, with a number of Mesolithic finds and Roman coins found in the area.

A small distance out to sea is the Great Mewstone (or Gull Rock), which has played a role as both a private home and a refuge for smugglers. The rock has also been a prison for one infamous local resident, who avoided transportation to Australia by agreeing to be imprisoned there.

A boat on the beautiful River Yealm at Newton Ferrers.

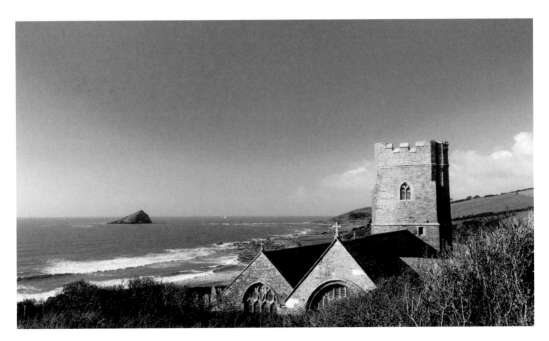

St Wurburgh's church at Wembury, overlooking the Great Mewstone.

The unspoilt wooded estuary of the River Yealm rises on the Stall Moor mires of southern Dartmoor, passing through Lee Mill and Yealmpton before meeting the sea at Wembury.

Plymouth

Prehistoric Beginnings

Plymouth is the largest city in Devon and marks the end of our journey along the South Devon Heritage Coast. Sitting in the shadow of Dartmoor, the modern city of Plymouth stretches over 4 miles from east to west and spans the estuaries of two rivers, the Tamar and the Plym. The Tamar has acted as the border with neighbouring Cornwall since AD 936, when King Æthelstan made Devon a shire of the Kingdom of England. The two rivers join at the coast, where they form the natural deep water harbour of Plymouth Sound, which has shaped the history of the city since ancient times.

Evidence found in limestone caves at Cattedown in 1886 show that long before the arrival of the city, the shores of Plymouth Sound have seen human settlement stretching back into prehistory. The skeletal remains of fifteen early humans, alongside worked flints and the bones of Ice Age animals such as woolly rhinoceros, hyenas and lions, are evidence of occupation dating back to the Stone Age. Some of the bones have been dated to 140,000 years ago, and represent some of the oldest remains of *Homo sapiens* ever found in Britain.

Other finds around Plymouth have provided evidence of human occupation throughout later prehistory, including tools from the Neolithic period (10,000 to 5,000 years ago) that were found around Mount Batten. Evidence from the Bronze Age (2,500 to 800 BC) include an early cemetery at Elburton and a small trading settlement at Mount Batten,

which was active from 1,000 BC right through to the end of the Roman period in AD 400. Exeter was the westernmost extent of the Roman Empire. However, the discovery of a number of Roman coins and a Romano-British settlement at Plymstock indicate that the Romans were regular visitors to the area in the early centuries AD.

Medieval Plymouth

Saxons settled in the area around Plymouth Sound soon after they arrived in South Devon during the seventh century AD, particularly around the sheltered inlets of Sutton Pool and Stonehouse Creek. By the arrival of the Normans at the end of the eleventh century, the Domesday Book records a small fishing village called *Sudtone* (old English for 'south farm') on the northern shores of Sutton Pool, around the current location of Old Town Street. This is likely to have been one of the original settlements founded by early Saxon settlers, and the origins of what was to become the city of Plymouth.

In the Norman period, the main population centre in the area was upstream on the River Plym at Plympton, its name meaning 'plum tree village' in Saxon English. With a Norman castle and a flourishing port trading in tin from the mines of Dartmoor, Plympton's importance was recognised by being granted a market in 1194, and by the priors of the priory (founded in 1121) being granted the Royal Manor of Sutton.

As Plympton's importance slowly declined (possibly because of the silting-up of the River Plym making it more difficult for shipping to navigate), a new settlement started to prosper further south on the river's estuary. With its natural deep water harbour and sheltered position, the village of Sutton soon began to develop as a trading port. References to a port on the estuary first appeared in 1211 when records show a shipload of wine being despatched from 'Plym mouth'. By 1254, the settlement of Sutton Prior had grown sufficiently important that it was granted a market by King Henry III, thus making it a town. By the late thirteenth century, the port at Plymouth (as it was increasingly known)

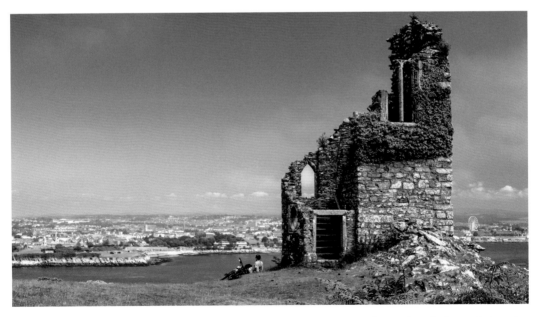

The ruins of a folly in Mount Edgcumbe country park overlooking Plymouth and Plymouth Sound.

gradually took over in importance from Dartmouth, thanks to a wider entrance and better land access. With a flourishing trade with France and increasing military use, the port brought great prosperity to the town, and it soon grew to become the second-largest town in Devon. As an indication of its growing importance, Plymouth sent its first representative to Parliament in 1298 and elected mayor in 1369.

An Age of Discovery

During the medieval period, Plymouth already had a trade network stretching across Europe. However, by the sixteenth century the town started to play a central role in a new era of worldwide exploration and discovery. The Pilgrim Fathers set sail from Plymouth in 1620 on board the *Mayflower*, searching for religious freedom away from the persecution of King James, and went on to establish the new colony of Plymouth, Massachusetts. Their story of victory over persecution is said to have sown the seeds for democracy in North America, and their famous voyage is commemorated by the Mayflower steps at Sutton Pool.

During the late eighteenth century, Captain James Cook sailed from Plymouth to explore the Southern Ocean and Pacific, and was the first explorer to set foot on the Hawaiian Islands. In 1831, Charles Darwin also sailed from Plymouth, bound for the Galapagos Islands, where he would formulate his revolutionary theory of natural selection. His work, *On the Origin of Species*, was published in 1859 and was pivotal in transforming our understanding of the natural world.

One of Plymouth's most famous explorers was Sir Francis Drake. Born in Crowndale in 1541, Drake was the first to circumnavigate the globe in 1577. Although all his ships except the *Golden Hind* were lost, he eventually returned with a huge haul of looted treasure. On his homecoming to Plymouth he received a hero's welcome, was knighted by Queen Elizabeth I and went on to become both an MP and Mayor of Plymouth. However, Drake is most famously remembered for his role in the defeat of the Spanish Armada.

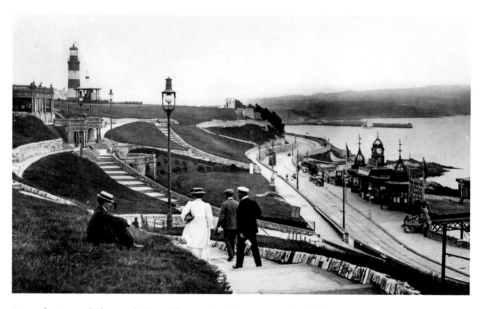

An early view of Plymouth Hoe. This postcard was posted in 1917.

In 1588, Spain assembled the largest war fleet ever seen and sailed for England, intent upon invasion and taking the English throne. A fleet of sixty English warships awaited the Armada in Cattewater, and it is famously reported that Drake calmly finished his game of bowls on the Hoe before beginning his attack on the Spanish fleet. It is likely there is an element of truth in this story, but the delay was most likely due to Drake waiting for suitable tide conditions, rather than simply playing it cool. Once at sea, Drake played a central role in the battle, firstly by capturing the Spanish Galleon *Rosario*, and then organising a fleet of fire ships to break the Spanish fleet formation and force them out into open sea. Bad weather then played a hand in the battle, forcing the Spanish fleet into the North Sea. The fleet tried to escape by sailing around the top of Scotland, but most ships were lost during the long and treacherous journey and many Spanish sailors never made it home. As one of the city's most famous sons, Drake is commemorated by a statue on Plymouth Hoe.

War and Defence

By the fourteenth century, Plymouth's increasing importance as a naval port made it increasingly vulnerable to enemy attack. Several French attacks on the town took place during the Hundred Years War, with the most significant being in 1403, when a large Breton force ravaged a part of the town now known as Bretonside. The attacks led to the development of new defences for Sutton, including a castle on a rocky spur above the barbican, a town wall and a chain to prevent enemy ships from entering the harbour. Little remains of Plymouth Castle today, except the ruins of two towers below the citadel and a depiction of the original four towers that appear on Plymouth's coat of arms.

The 1640s brought the English Civil War to Plymouth and, like most Devon towns, a general dislike of royalty meant the town's population were firmly on the side of the Parliamentarians. Since rural Devon was staunchly Royalist, Plymouth became isolated, with the town besieged almost continuously from 1642 to 1646. Although this led to great hardship for the people of early Plymouth, the town survived thanks to the Navy retaining control of the port, allowing vital supplies to continue to arrive into the besieged town from the sea. The last major attack on the town was by a huge Royalist force led by Sir Richard Grenville in 1644. Grenville's forces were soundly defeated by the people of Plymouth, and in 1651 the Parliamentarians went on to victory in the wider Civil War. However, the victory was short-lived and by 1660 King Charles II had restored the monarchy to England and had imprisoned the victorious Parliamentarian leaders, many on Drake's Island on Plymouth Sound.

By 1771, one of Plymouth's most iconic defensive structures, the Citadel, had appeared in its prominent position overlooking the town. Replacing an earlier fort constructed on the Hoe around 1596, the citadel was built at the highest part of the town in order to defend the entrances to Cattewater and Sutton Harbour. The Citadel was armed with 113 cannons, some of which pointed towards the town, allegedly as a reminder to the rebellious residents of Plymouth to never again oppose the Crown. So important was Plymouth and its defences that King Charles II visited twice in 1671 and 1677 to inspect the Citadel.

A History of Seafaring

Plymouth's history has been linked to the sea for many centuries, and the worldwide influence of those who sailed from its ports can be seen by Plymouth having given its name to forty towns and cities all over the world. By 1588, the town also began to take on national military importance when it became the main base for the naval fleet preparing for an assault on the Spanish Armada. This was to bring great prosperity to Plymouth, and marked the start of a history of protecting the South West approaches that would endure for over 400 years.

Although Plymouth's prosperity declined after the Spanish wars, it was once again war that renewed the town's military importance. In 1689, Prince William of Orange came to the

throne as King William III and immediately ordered that a new naval dockyard be established in the West Country in order to repair and replenish his naval fleet. Plymouth's existing port at Cattewater and the nearby port at Dartmouth were both dismissed, and in 1690 an area of marshland bordering the River Tamar was chosen as the site of a new naval dockyard. Further developments were made to the dockyard during the eighteenth century and a huge naval complex began to develop, supported by the new town that began to grow up around it. The dockyard played a critical role in the Napoleonic Wars of the early nineteenth century, and the new town, then called Plymouth Dock, grew to be larger than Plymouth and the main source of employment in the area. By 1824, the Plymouth Dock was renamed as the more familiar Devonport, and in 1928 the towns of Devonport, Stonehouse and Plymouth were merged to create the modern City of Plymouth. Over 400 years of naval history endure right to the present day in the shape of Her Majesty's Naval Base (HMNB), which still operates from Devonport.

Surviving the Blitz

Plymouth was badly affected by the Second World War, suffering severe bombing that brought destruction and loss of life on an enormous scale. The city was a prime target due to the military importance of the Devonport shipyards in the battle for the Atlantic supply routes, which were critical to keeping Britain supplied throughout the war. Plymouth was also one of the most bombed cities for its size, with the German Luftwaffe carrying out fifty-nine bombing raids between 1940 and 1944. The raids killed more than 1,000 people and destroyed 10,000 buildings, including the whole of the city centre and many of Plymouth's historic buildings. The damage was so severe that returning servicemen were said to have found it hard to recognise the city that they had left. Such was the effect on the city that the 300-year-old Charles church, which was largely destroyed by incendiary bombs during a raid in 1941, was deliberately left in its ruined state as a memorial to those who had perished.

The historic Plymouth Gin Distillery in the Barbican, in operation since 1983.

Despite the devastation of the Blitz, hints of Plymouth's history can still be found within the city's streets and buildings, especially around Sutton Pool, which escaped the worst of the bombing. Plymouth prospered during the Spanish wars, with its population doubling between 1580 and 1600 and a large amount of new development taking place around Sutton Pool. This included the area of present-day New Street, which is the oldest remaining part of the city, and retains much of its Elizabethan splendour with winding, cobbled streets and a number of sixteenth-century timber-fronted merchants' houses. One of the oldest buildings is the so-called Elizabethan House at No. 32 New Street, built in 1584 and recently restored to how it would have looked in the sixteenth century. One of the house's most famous owners was William Parker, an Elizabethan sea captain who moved there in 1608 after a life of adventure at sea, including sailing with Drake on the *Mary Rose* during the defeat of the Spanish Armada.

The oldest building in Plymouth is the Prysten House ('Priest's House') located behind St Andrew's church, which was built in 1490 by the priors of Plympton as a lodging house for the priest. Other remnants from Plymouth's past include F. J. Jacka's bakery in Southside Street. The oldest working commercial bakery in the world, Jacka's is thought to have been baking in the late sixteenth century, and may have provided provisions for the Pilgrim Fathers. Another relic is the building that has housed the Plymouth Gin Distillery since 1793. Originally built in the early fifteenth century as a monastery for Black Friars, local folklore says that the Pilgrim Fathers spent their last night in England at the monastery in 1620.

On the Hoe is the distinctive shape of Smeaton's Tower, which was originally built far out to sea as a lighthouse to warn shipping off the treacherous Eddystone Rocks. The tower was later moved piece by piece to the Hoe in the early 1880s, after the rock upon which it had been built was seriously eroded by the sea. Near to Smeaton's tower are a number of memorials marking Plymouth's long military history, including memorials to the casualties of the two World Wars, and the National Armada memorial commemorating Britain's defeat of the Spanish Armada.

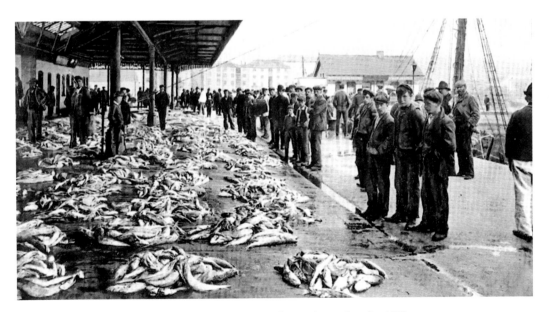

An early image of fish on sale at the Barbican, Plymouth, produced *c.* 1910.

Buildings on Plymouth's historic Barbican, overlooking Sutton Harbour.

Statue of Sir Francis Drake on Plymouth Hoe with the Naval War Memorial in the background.

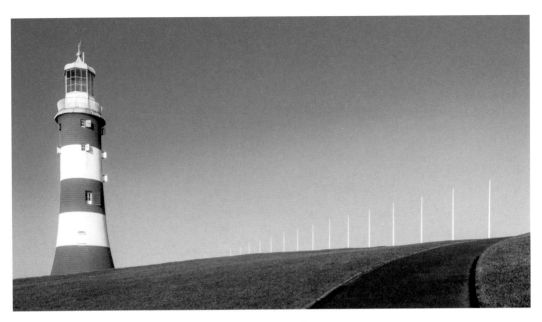

The iconic Smeaton's Tower on the slopes of Plymouth Hoe.

The River Tamar is spanned by the iconic Royal Albert Bridge, designed and built by Isambard Kingdom Brunel, and was opened by Prince Albert in 1859, with the modern Tamar road bridge added in 1962. The river's name is a derivation of a prehistoric word for river, meaning 'dark flowing', and the Tamar has marked the border between Devon and Cornwall since AD 936. The river also marks the end of our journey along the South Devon Heritage Coast.

References

Books
Border, M., C. Proctor, J. Risden, *The Official Guide to the English Riviera Global Geopark* (2010)
Hesketh, R., *Devon's History* (2009)
Hesketh, R., *Plymouth: A Shortish Guide* (2010)
Hoskins, W. G., *Devon* (2003)
Whitton, Jack, *Torbay: The Visible History* (2001)

Websites
A Vision of Britain Through Time (*http://www.visionofbritain.org.uk/*)
A World History Encyclopedia (*http://www.localhistories.org/*)
About.com (*http://www.gouk.about.com/*)
Areas of Outstanding Natural Beauty (*http://www.aonb.org.uk/*)
Babbacombe Cliff Railway (*http://www.babbacombecliffrailway.co.uk/*)
BBC (*http://www.bbc.co.uk/*)
Big Hearted Brixham (*http://www.brixham.uk.com/*)
Bigbury on Sea (*http://www.bigburyonsea.com/*)
Brunel 200 (*http://www.brunel200.com/*)
Castles and Fortifications of England & Wales (*http://www.ecastles.co.uk/*)
Cinemaquatics (*http://www.cinemaquatics.co.uk/*)
Cream Tea Café (*http://www.creamteacafe.com/*)
Dartmouth Higher Ferry (*http://www.dartmouthhigherferry.com/*)
Dawlish Warren (*http://www.dawlish-warren.co.uk/*)
DawlishWarren.co.uk (*http://www.dawlishwarren.co.uk/*)
Devon County Council (*http://www.devon.gov.uk/*)
Devon Guide (*http://www.devonguide.com/*)
Devon Heritage (*http://www.devonheritage.org/*)
Devon News Centre (*http://www.devonnewscentre.info/*)
Devon Online (*http://www.devon-online.com/*)
Devon Perspectives (*http://www.devonperspectives.co.uk/*)
Devon Rigs Group (*http://www.devonrigs.org.uk/*)
Discover Dartmouth (*http://www.discoverdartmouth.com/*)
East Portlemouth (*http://www.eastportlemouth.org.uk/*)
English Apples & Pears (*http://www.englishapplesandpears.co.uk/*)
English Historical Fiction Authors (*http://www.englishhistoryauthors.blogspot.co.uk/*)
English Riviera News (*http://www.englishrivieranews.com/*)
Essentially England (*http://www.essentially-england.com/*)
Exclusively Dartmoor (*http://www.exclusivelydartmoor.co.uk/*)

Exeter Memories (*http://www.exetermemories.co.uk/*)
Helium (*http://www.helium.com/*)
InfoBritain (*http://www.infobritain.co.uk/*)
Jurassic Coast (*http://www.jurassiccoast.org/*)
Knoji Consumer Knowledge (*http://www.localreviews1.knoji.com/*)
Landmark Trust (*http://www.landmarktrust.org.uk/*)
LiveScience (*http://www.livescience.com/*)
Marine Tavern Dawlish (*http://www.marinetaverndawlish.com/*)
Natural England (*http://www.naturalengland.org.uk/*)
Newton Ferrers & Noss Mayo (*http://www.newtonnoss.co.uk/*)
Parish of Dartmouth (*http://www.parishofdartmouth.co.uk/*)
Phil Scoble (*http://www.philscoblehistorian.wordpress.com/*)
Pictures of England (*http://www.picturesofengland.com/*)
Pirate Attack (*http://pirateattack.co.uk/*)
Plymouth City Council (*http://www.plymouth.gov.uk/*)
Plymouth Data (*http://www.plymouthdata.info/*)
Plymouth Devon 4U (*http://www.plymouthdevon4u.co.uk/*)
Plymouth Gin (*http://www.plymouthgin.com/*)
Project Britain (*http://www.projectbritain.com/*)
Royal Geographical Society (*http://www.rgs.org/*)
Royal Naval Museum (*http://www.royalnavalmuseum.org/*)
Salcombe Information (*http://www.salcombeinformation.co.uk/*)
Shaldon Devon (*http://www.shaldon-devon.co.uk/*)
Smugglers' Britain (*http://www.smuggling.co.uk/*)
Smuggling – South Hams, Devon (*http://www.smugglingsouthhams.wordpress.com/*)
South Devon Area of Outstanding Natural Beauty (*http://www.southdevonaonb.org.uk/*)
SouthHams24.co.uk (*http://www.southhams24.co.uk/*)
South West Coast Path Association (*http://www.southwestcoastpath.org.uk/*)
Starcross Yacht Club (*http://www.starcrossyc.org.uk/*)
Stokenham Parish Council (*http://www.stokenham-pc.gov.uk/*)
Stretewise (*http://www.stretewise.co.uk/*)
Subterranean History (*http://www.subterraneanhistory.co.uk/*)
Teignbridge District Council (*http://www.teignbridge.gov.uk/*)
The Cricket Inn (*http://www.thecricketinn.com/*)
The Great War, 1914–18 (*http://www.greatwar.co.uk*)
The Heritage Trail (*http://www.theheritagetrail.co.uk/*)
The Historic Teignmouth – Shaldon Ferry (*http://www.teignmouthshaldonferry.co.uk/*)
The Megalithic Portal (*http://www.megalithic.co.uk/*)
The Real Cider & Perry Page (*http://homepage.ntlworld.com/scrumpy/cider/*)
The Teign Catchment (*http://www.teign-catchment.co.uk/*)
The Way of the Pirates (*http://www.thewayofthepirates.com/*)
The World at War (*http://www.1939-45.co.uk/*)
Torbay Council (*http://www.torbay.gov.uk/*)
Torbytes (*http://www.torbytes.co.uk/*)
Torquay (*http://www.torquay.com/*)
Torre Abbey (*http://www.torre-abbey.org.uk/*)
Trinity House (*http://www.trinityhouse.co.uk/*)
University of Southampton (*http://www.southampton.ac.uk/*)
Visit South Devon (*http://www.visitsouthdevon.co.uk/*)
Visitor UK (*http://www.visitoruk.com/*)

Welcome to Kingswear (*http://www.kingswear-devon.co.uk/*)
Wikipedia (*http://www.en.wikipedia.org*)

Image Sources
Library of Congress (pages 25, 30, 39, 53, 64, 93)
© Public Library of Science (page 14)
South West Coast Path Assocation (page 2)